Basic Perspective
for Artists

Basic Perspective for Artists

A Guide to the Creative Use of Perspective
in Drawing, Painting, and Design

Keith West

Watson-Guptill Publications/New York

Originally published in the United Kingdom in 1995 by
The Herbert Press Ltd as *Creative Perspective for Artists and Designers.*

Copyright © 1995 by Keith West

First published in the United States
in 1995 by Watson-Guptill Publications,
a division of BPI Communications, Inc.,
1515 Broadway, New York, NY 10036

Cataloging-in-Publication Data is available from the Library of Congress.

ISBN 0–8230–0442–2

Manufactured in Great Britain
First printing, 1995

2 3 4 5 6 7 8 9 / 03 02 01 00 99 98 97 96

Contents

To Janice and Ken

Introduction

This book is intended for artists, illustrators and designers, whether be-
ginners or professionals. In particular, it is for those who, although keenly
interested in art, have in the past missed instruction in perspective. Their
work may show that the issue is often avoided – by restricting the subject-
matter or by choosing a style for which accurate perspective is irrelevant.
The following chapters aim to make such tactics unnecessary.

Perspective in pictures can be defined as a means by which an impression
of three dimensions is produced upon a two-dimensional plane. For any
object to be represented realistically, it has to be in perspective. In the art of
early civilizations there existed a convention of portraying subjects more
or less flat, with all components at the same apparent distance from the
observer. This method of representation was most developed in the wall
paintings of Pharaonic Egypt, made over a period of some three thousand
years. These otherwise sophisticated murals show no attempts to suggest
depth in any way that we find convincing.

The ancient Greeks were familiar with perspective, as seen on some vase
paintings of the fifth century BC and in fourth-century wall paintings.
Roman mosaics and paintings at Pompeii and elsewhere are clearly based on
Hellenistic tradition. Some have architectural features drawn in perspective
which indicate an understanding of the rules involved.

With the growing ascendancy of Christianity, artistic work was influenced
by the formal symbolism of Byzantine iconography, which gave no scope for
perspective. In the following centuries, throughout Europe, the main con-
tinuing employment for pictorial artists was in the illumination of sacred
works under monastic patronage. Superbly decorated manuscripts often in-
cluded miniature scenes for which perspective might have been appropriate,
but it appears that a need for realism was not felt again until the beginning
of the Renaissance.

In India and China artists found different ways of indicating spacial
relationships. In India, in some surviving cave paintings from the sixth
century AD at Ajanta, there is evidence of attempts to find perspective
solutions. Parallel lines were projected as converging – even if towards
multiple horizons. The Chinese approach seems more eccentric and sub-
jective to us, because the eyelevel line by implication is *behind* the observer,
so that rectangular buildings etc. appear to become narrower at the front.

In Europe, the rebirth of naturalistic painting and the development of perspective began in Italy in the thirteenth century with the Renaissance. From then until the twentieth century, it was assumed that all artists would have a command of perspective. In this century, new movements in art set aside or ignored perspective knowledge. The validity of these newer schools has been long established, as have the reputations of the major exponents. Yet despite the artistic and social turmoil, representational art survives and flourishes, and many well-loved artists continue to use traditional methods for individual modes of expression.

This book should enable you to use perspective accurately as part of your foundational skills, and by following the demonstrations and examples given, you should find that worthwhile results can be achieved without superfluous effort. A brief chapter on anatomy for the artist is also included. Bone structure and musculature are responsible for the wonderfully subtle lines of the body and some knowledge of their interaction is necessary for the student who wants to depict the human body realistically and in perspective.

I hope that you will find much to enjoy in the following pages. Though a ration of mundane material occurs along the way, most of the drawings throughout the book are made from my imagination and some readers, particularly illustrators and designers, will work in the same way. My advice to most artists is to work from life as far as possible; but the range of subject matter included here meant that I was not always able to rely on nature or my surroundings as a source. I hope that delving into my imagination may have added an extra dimension.

1 Basic principles

This chapter is for beginners and is concerned with some basic principles of drawing and perspective.

Drawing is the basis of pictorial art, and progress can only be made with constant practice. All you need to start with is paper, pencils and a drawing board. When you have made some progress, you will probably want to experiment with different media and drawing tools. Begin by practising a variety of strokes: swirls, circles, straight lines, etc. Involve your whole arm, with movements originating from the shoulder, as this helps to avoid tension and cramp.

To begin with, choose a simple form as your subject – nothing too small and fiddly. The image on your paper should certainly not be less than 15 cm long, preferably much larger. A good first subject would be a fairly large leaf, perhaps from a pot plant. This has an interesting outline that will vary according to the angle and height from which it is viewed. You could make a series of outline sketches and then develop one of these as shown in fig. 1.

1 *a–d* Stages in drawing; *e* hatching; *f* continuous tone

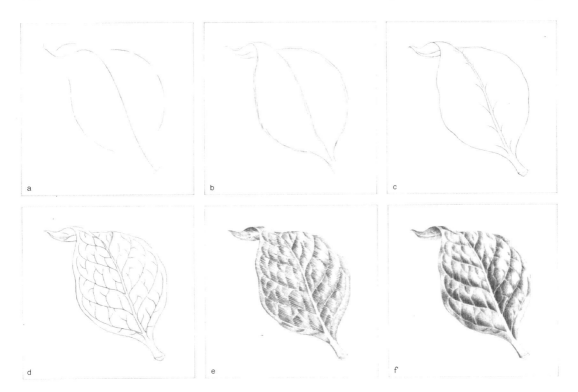

Basic perspective

opposite
2 Ten basic points of
perspective

However you approach perspective as a beginner there are ten basic points to consider (fig. 2):

1 The image seen will vary according to the observer's eyelevel (EL) and position in relation to the object viewed.
2 As objects recede they appear smaller.
3 Parallel lines that are also parallel to the observer do not appear to converge, though they will appear progressively closer with increasing distance until they optically merge.
4 Parallel lines that recede from the observer appear to converge.
5 Converging parallels appear to meet at a vanishing point (VP) on the line of the observer's eyelevel when the parallels are also on or parallel to the ground plane.
6 Inclined converging parallels appear to meet at a vanishing point above the eyelevel where the slope rises above the ground plane, and below the eyelevel where the slope descends beneath the ground plane.
7 One vanishing point is used when rectangles or rectangular solids are placed on or parallel to the ground plane with the near side parallel to the observer.
8 Two vanishing points are used when rectangles or rectangular solids are placed on or parallel to the ground plane with their near corner at an angle to the observer.
9 Three vanishing points may be needed when you look up or down at a steep angle to a rectangular solid, or when it is distinctly tilted in relation to the ground plane.
10 Foreshortening is the effect in perspective by which receding surfaces appear shorter than their true measure.

All the above topics are elaborated and explored in the pages that follow.

Composition

Composition – the way the components of a drawing are arranged – is important. There are many ways in which a pleasing balance, or sometimes an interesting dissonance, may be achieved. Even placing a simple subject on a sheet of paper involves a compositional choice. Usually, for a single form, the surrounding blank space should be approximately equal at the top and sides, with a little extra at the bottom; but there are occasions when the subject may best be placed higher or lower, to one side or the other. In any picture area the artist is forced to accept the challenge of creating within constant parameters.

With a single subject, the question of a focal point or centre of interest does not usually arise. But in a composition using two or more elements, the artist may channel the eye along particular routes before reaching the centre

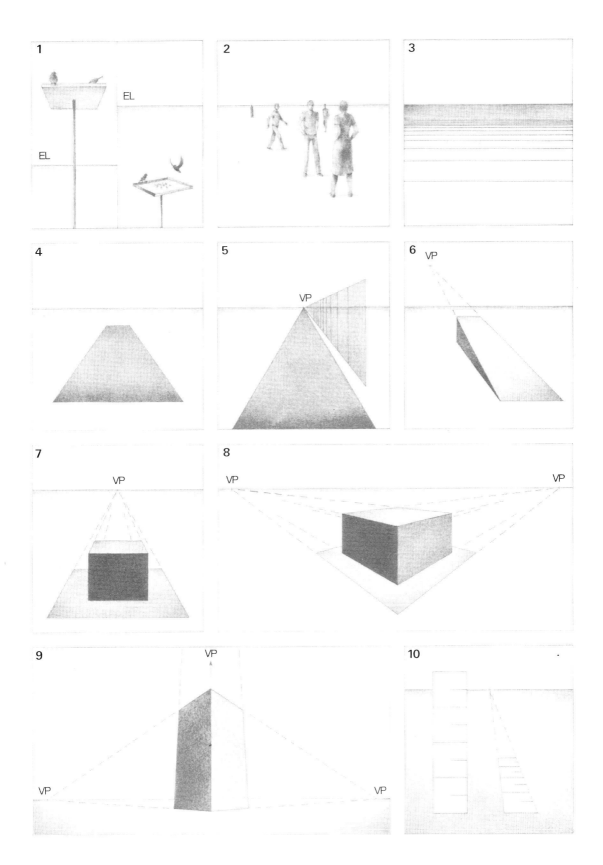

3 Dividing the picture plane
and centres of interest

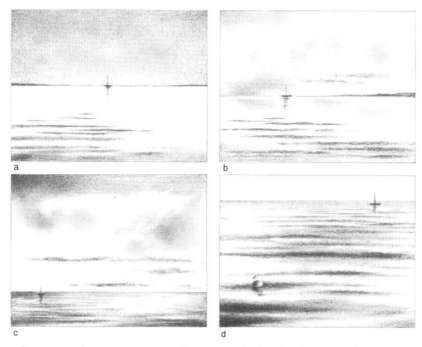

of interest – the most important feature. In the hands of a master this is often
a matter of intentional subtlety and expertise; yet even for those less gifted
it is surprising how unexpected harmonies and felicities occur without
conscious volition as the composition is built up. By recognizing and re-
taining such bonuses, your level of artistry will be enhanced. In many works
of art there may be several centres of interest, so that the eye is allowed to
wander, pausing occasionally but without being dominated by any one part.

Fig. 3 shows several ways of dividing the picture plane and placing centres
of interest. 3*a* shows a situation normally to be avoided: sea and sky each
occupy half the picture area, and the focus is uncomfortably at the geometric
centre. In *b*, the proportions are pleasing, if familiar. Sketches *c* and *d* show
less clichéd arrangements. Colour may be as important as form in defining
a centre of interest. In *d*, the small buoy in the foreground would capture
the attention if it were bright red. These small drawings show only the most
elementary divisions of the picture area, with a straightforward focal point,
and many successful compositions are no more complex. Yet when a com-
position becomes more subtle it may contain internal rhythms involving
circles, spirals, triangles and other forms and combinations.

Every pictorial element in a composition carries its own subjective
impression. A few examples are illustrated in fig. 4. In *a–c*, the main com-
ponents give different messages – in addition to those conveyed by the overt
subjects. In *a*, a dominant vertical movement is suggested by the spires.
Pictures comprised largely of verticals tend to have an atmosphere of dignity
and calm, of reaching upwards. In *b*, horizontals bounded by short verticals
in the plain buildings speak of stability and a certain heaviness. No move-
ment appears likely, but if it were to be indicated by the addition of wheels

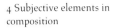

4 Subjective elements in composition

a b

c d

etc., it would have to be lateral. The floating logs in *c* show the power of diagonals, giving a definite sense of movement. Diagonals are useful in compositions requiring this kind of dynamic. The logs convey a feeling of stately progress, perhaps because the water is smooth, but with a few more touches they might appear to hurtle either towards or away from the observer.

A balance is achieved in *4d* because each subjective movement is countered. The strong perpendiculars of the trees are anchored by the weight of the horizontals in both the foreground and background. The tops of the trees also serve to block the lightly curving sweep of the high clouds. Repetition, seen in the row of trees, builds pleasing rhythms (see also *b* and *c*). The bands of dark shadow in the foreground and middle distance, as well as the background trees, help to unify the composition. (The use of dark tone to link disparate elements should not be over-used.)

Other subjective forces are at work in *4d*. Notice how your attention is tugged insistently by the figures, even though the large tree on the left may initially catch the eye. Then again and again you seem compelled to focus on the distant cottage – the prime centre of interest. Although isolated figures always attract the eye, in this instance it is channelled back into the picture by two forceful subjective lines, one following the bases of the tree trunks and the other the tops of the trees, which converge at the cottage.

There is not space here to do more than touch on the fascinating subject of composition, but you can learn much by trying to analyse how the drawings and paintings of the great masters succeed in this respect.

2 Concepts

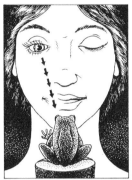

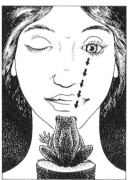

5 Different view from each eye

The word 'perspective' is derived from the Latin *perspicere* – to look through or to view in depth. We can perceive objects in three dimensions because we have binocular vision. Owing to their distance apart, our eyes each receive a slightly different image (fig. 5). These individual images are continuously mentally fused to provide our view of the world in depth. The duality of the images may best be appreciated by closing or covering each eye in turn while looking at a particular object close by in relation to its background. Apart from the information given by binocular sight, we are also given visual clues as to distance by overlapping features (fig. 6), and the diminution of tone with absorption of colour (see aerial perspective pp. 22–3).

It may seem odd that, given our three-dimensional awareness, we have to turn to monocular vision in order to set down in pictorial form what we see. Yet when working from nature on a two-dimensional surface this is a practical necessity. In transferring the apparent dimensions of components of the scene to the drawing surface, several techniques are used (fig. 7). For each, one eye provides a single viewpoint. Most readers will be familiar with such strategies and so they are mentioned only briefly here. In fig. 7*a*, a pencil held with the arm at full stretch measures relative proportions and assesses angles. Transparent sheets marked with grids may be used for the same purpose (*b*). Another simple process is to project key points directly on to the sheet (*c*).

The translation of the proposed subject into a picture is normally fairly straightforward, given a certain facility, and provided that the topic is not too complex. As for perspective, the basics may easily be recognized and followed once they have been absorbed. For many artists, interpreting reality

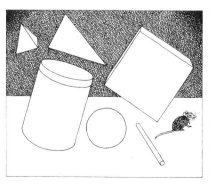

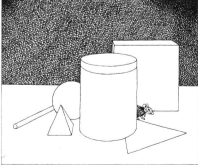

6 Overlapping suggests relative positions in depth

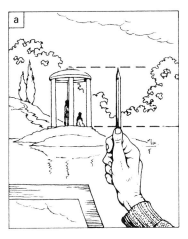
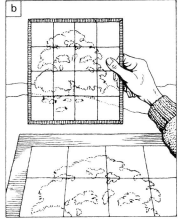

7 Drawing aids

provides unlimited stimulating and challenging subjects (fig. 8a). In contrast, others choose to work wholly or predominantly from the imagination (b). Where an imagined scene is to be given a realistic treatment, a more developed fluency in perspective is required from the artist. He or she will adopt, without conscious volition, the usual pre-conditions of a fixed viewpoint and monocular vision to begin to build a believable pictorial construct. The concepts discussed here will be incorporated, forcing innumerable choices along the way. Of course, in creating such pictures, material from various reference sources may be used, and these also have to be interpreted and amended to fit the selected perspective framework.

8 Working from actuality and from the imagination

a　　　　　　　　　　　　　b

Cone of vision

When you are working from life, the area in front of you that is included in your picture will be determined by your cone of vision, as shown in fig. 9. The angle of the cone is agreed by convention to be 60°, and this figure is adopted here for use where relevant. In reality the angle is much narrower. Research has shown that a horizontal angle of 37° and a vertical angle of 28° approximate reality – though these figures are less practical in use. Since you may work successfully without awareness of your cone of vision, its introduction might seem academic. Yet, as will be clear later, especially in working from the imagination on complex perspectives, the concept of a cone of vision becomes vital.

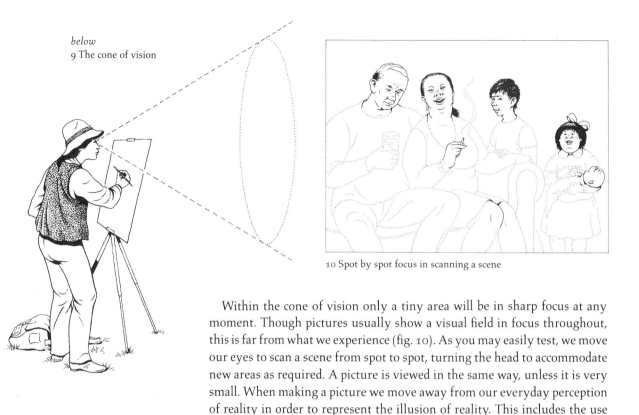

below
9 The cone of vision

10 Spot by spot focus in scanning a scene

Within the cone of vision only a tiny area will be in sharp focus at any moment. Though pictures usually show a visual field in focus throughout, this is far from what we experience (fig. 10). As you may easily test, we move our eyes to scan a scene from spot to spot, turning the head to accommodate new areas as required. A picture is viewed in the same way, unless it is very small. When making a picture we move away from our everyday perception of reality in order to represent the illusion of reality. This includes the use of perspective, which operates through certain conventions – principally, the assumption mentioned earlier of monocular vision from a fixed viewpoint.

To make perspective work, you should be aware of a particular limitation: when you move away from the area around the centre of vision, CV, within

11 Progressive distortion

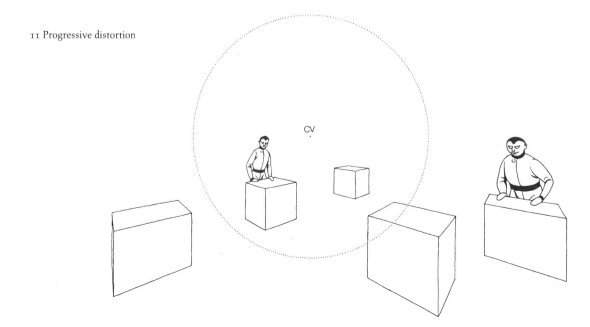

12 Distortion-free cubes
within the cone of vision

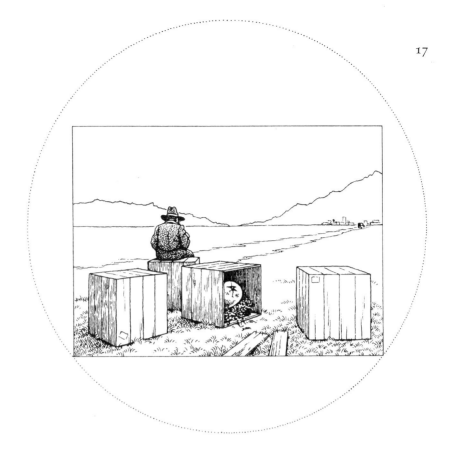

the cone of vision, distortion becomes progressively greater. This is shown in fig. 11, where the circle is a cross section of the cone of vision at the picture surface. The extent of the area covered by the circle is clearly a function of the distance from the eye. In the diagram, within the cone of vision there are two carefully constructed cubes. The other forms outside the circle, though made using the same parameters (p. 45), are not convincing cubes. To emphasize this point the robot-type figure within the circle is repeated outside to demonstrate lateral distortion. This type of peripheral distortion is common in photographs taken with a wide-angle lens.

It is obvious, therefore, that the picture area should be sited comfortably inside the cone of vision, as shown in fig. 12. The cubes in this sketch appear as we might expect to find them in reality.

Picture plane

The picture plane, fig. 13, may be imagined as a transparent plane at right angles to your central line of vision. Think of it as a sheet of glass through which you see the picture to be transcribed on to your drawing surface. As already noted, when working from nature you may work without being aware of your cone of vision, and the same is true of the picture plane. In designing an imagined detailed perspective, however, both concepts are useful to keep in mind.

In fig. 13, the size of the picture plane and the distance from the observer were matters of convenience. When starting a composition, the picture plane

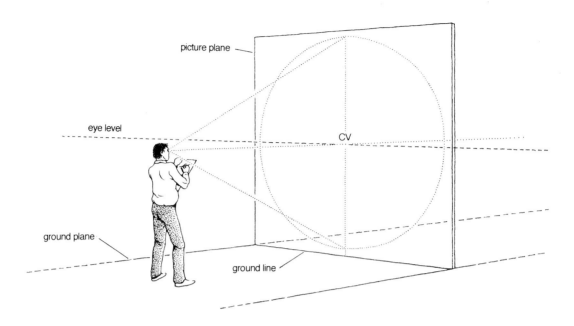

picture plane

eye level

CV

ground plane

ground line

13 The picture plane

may be imagined at any relevant scale and position. It is usually placed on the ground plane with the base forming the ground line.

Eyelevel

An eyelevel line for the observer is also shown in the diagram. As described in detail in chapter 3, the placement of this line directly affects the appearance in perspective of any given scene. For the moment, simply imagine a line that remains constantly level with your eyes whatever your position. In fig. 14 the eyelevel is that of the man, and because the setting is the seaside this line is also that of the horizon – the two are coincident where there are no obscuring features such as hills etc. A child, dog, and gull are included to stress that from their relative positions the view would be quite different: the gull would see a greater expanse of water than the man; for the child the spread of sea would be apparently condensed, and this effect would be increased for the dog.

Notice that in fig. 14 the centre of vision, CV, is on the eyelevel line. This is always so when we look straight ahead, but as indicated in fig. 15, if the head is tilted up or down, the centre of vision (and picture plane) moves correspondingly. There are perspective complications resulting from such movements and these are treated in chapter 5.

Diminution

The most obvious effect of perspective, and a prerequisite for us to move around safely, is the seeming diminution of objects as they recede from us. Fig. 16 illustrates the optical reason for this phenomenon. Two transparent spheres of the same size, represented as circles, are placed one behind the

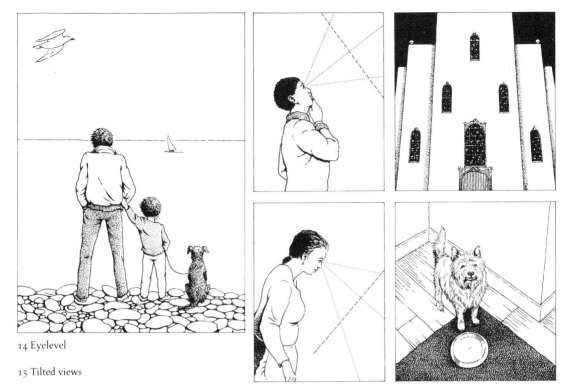

14 Eyelevel

15 Tilted views

16 Optical cause for an apparent reduction in size with distance

other. They are viewed by a man positioned in direct line with the spheres on the far side of a sheet of glass. The concentric ellipses on the glass are the outlines of the spheres as they might have been traced by the man from his position. They appear elliptical only from our viewpoint; he would, of course, see them as concentric circles. The dotted lines from the outer edges of the spheres show the paths of light rays that meet at his eye. The tracks of these rays, together with the images on the glass, show why the further sphere appears smaller to the man than the nearer one. In contrast, from our position the spheres are equidistant and therefore equal in size – though the radiating lines cause one to appear larger than the other.

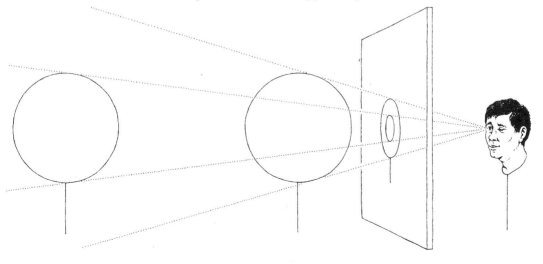

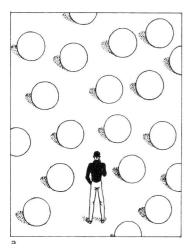

a

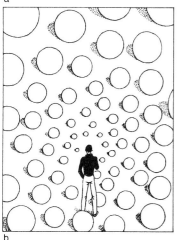

b

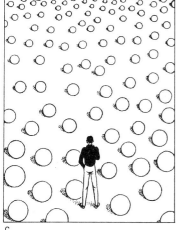

c

17 Alternative perspectives?

It is hard to conceive of existence in other dimensions where light might behave according to different rules, and therefore present alternative perspectives. I have tried to picture two hypotheses in fig. 17a, and b, compared to 'normal' perspective in c. In a, same-sized spheres all keep their apparent size no matter what their distance from the man. The globes in b, though intended to represent a single size, were drawn to appear to increase in volume with recession. Oddly, after making the diagrams, my mind still attempted to interpret a and b in terms of present reality: there is an illusory impression that in a the objects furthest from the figure were slightly larger than those close by; in b, a feeling persists that the man stands at the bottom of a bowl-shaped concavity.

In infancy we become aware of three-dimensional space through binocular vision, then by empirical knowledge of diminution etc. we learn to judge the relative positions of elements in our surroundings. This facility gives us very fine discernment – as applied in picking up tiny items or in throwing balls to a target. Given this skilled judgement it is curious that we are able to accept quite wide departures from accurate perspective without being aware of deviation. Fig. 18 illustrates something of the flexibility of perception.

I began with sketch a, using certain criteria: the figures were considered to be of equal height, as were the stones. But for the purpose of the exercise I intentionally fudged and distorted the perspective. Sketch b shows a corrected view. To aid comparison I wanted to keep the bases of all the stones in the same positions as before. This meant that I had to adjust all the heights using the closest menhir and monk as guides. The way to do this in perspective is detailed on p. 123. Sketch a might appear just as valid as b if the parameters were not given – both stones and monks would be accepted as being of various sizes. Yet even with knowledge of the ground rules, one might argue for a more or less correct perspective by straining a little. For instance, the giant monk with a staff would not be found so tall if it were understood that he and his stone were closer to the eye than they appear – on a slight rise, for example. This is the sort of reasoning that we make unconsciously in evaluating what we see. In nature all things *must* be in correct perspective because there is no alternative. Thus it is that when we look at pictures we may tolerate quite wide divergence from the strictures of reality by making numerous subliminal concessions and adjustments.

An important side issue is also unintentionally demonstrated in fig. 18. While translating a into b, I concentrated almost solely on the main task of correcting perspective, and failed to see that I was losing an intriguing and slightly menacing atmosphere that had been present in a; this should have carefully been developed rather than dissipated. Here is a cautionary example of how the promise of a rough sketch may be lost if one is not aware enough of the stronger facets which should be preserved in the finished work.

18 Flexibility in perspective

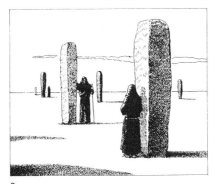 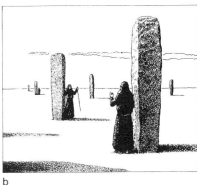

a b

Convergence

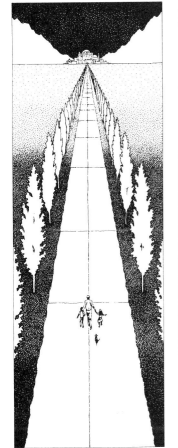

The next most obvious perspective phenomenon, after that of the diminution of objects with recession, is that of convergence. Briefly, convergence is seen most clearly where parallel lines recede from the observer; conversely, parallel lines placed parallel to the picture plane do not appear to converge. The usual cliché demonstrating both conditions is that of railway lines running to the horizon – the rails converge, the sleepers do not. Fig. 19 illustrates the principle. Notice also that with distance all components, not just the receding parallels of the road edges, are increasingly closer together, for example the trees and the horizontal markings. Further aspects of the perspective convergence of parallels are treated in chapter 4.

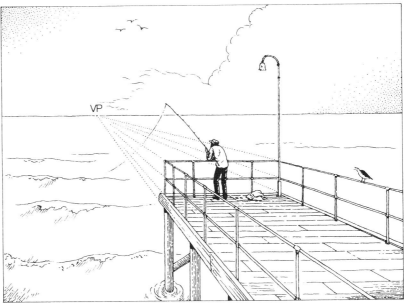

19 Convergence

20 Lines projected to a vanishing point

Vanishing point

If you follow receding converging parallel lines to the point where they appear to meet, as in fig. 19, you will have arrived at their vanishing point, VP. Though such situations are occasionally seen, more commonly parallels stop well short of their vanishing point. In making a perspective construction it then becomes necessary to project lines in order to establish the position of the VP – as shown in fig. 20. Vanishing points are always located along the eyelevel line, EL, provided that the parallel lines follow a path parallel to, or on, the ground plane. Objects with inclined or declined surfaces will have vanishing points above or below the eyelevel line. The importance of vanishing points is explored in chapter 4.

Foreshortening

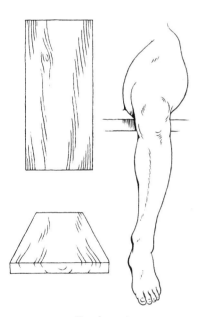

Foreshortening is an important effect of perspective. It is an apparent lessening in the length of an object according to its position in relation to the eye. On the left of fig. 21 is a simple example: a piece of wood is viewed in plan as if seen from directly above, with its apparent size being determined by its distance from the eye. In the sketch below, the board is seen from one end but almost at eyelevel, so its length seems shorter. This foreshortening effect is to be seen throughout the illustrations in this book.

An easy demonstration of foreshortening can be done if you take this volume, hold it horizontally well below your eyelevel, then slowly raise it. As the eyelevel is approached, the upper surface is increasingly foreshortened until its edge alone is visible when the book is level with your eye. In general such regular geometric shapes are not demanding to draw correctly foreshortened – though there is a tendency to show the object longer than it should appear. Irregular or organic forms are much more challenging. A strongly foreshortened thigh is shown in fig. 21, although any part of the body or, for that matter, a leaf or branch etc. would have been equally appropriate. If you wish to include such subjects in a composition it is wise to use a model or photo reference, until you gain considerable experience. It is always preferable to work from life in assembling a composition – living forms are inexhaustible in complexity and surprises. A foreshortened flower petal has greater subtlety of form than many buildings.

21 Foreshortening

Aerial perspective

Aerial perspective is also a concept that may be described here to avoid the necessity for expansion later in the text. The term was first used by Leonardo da Vinci in his exploration of the effects of the atmosphere and distance upon tone and colour. Tone in this context means the value of light to dark in all colours – the lightest tone is white, the darkest, black. In the gradation at the base of fig. 22, tone is taken to about the mid-point of the possible scale. Yellows are inevitably light in tone; other colours may be very deep-toned – as exemplified by dark blues or purples. Tonal structure may be a major consideration in successful picture making, but can only be touched on here.

Leonardo noted how the atmosphere absorbs colours, diminishes tones and blurs detail. The monochrome sketch in fig. 22 shows how tone normally fades with distance – each plane in recession being lighter than the one before. The scene is idealized, but the principle is frequently seen in operation. As for colours, the atmosphere absorbs them discriminately: reds and yellows disappear first, others follow until only a light blue persists in distant hills. This is the usual progression unless the sun is at a low elevation, as at dawn and sunset, when a landscape may be flooded with a scarlet or gold cast. Atmospheric conditions, including humidity, pollution etc., affect the rate of both tonal fading and colour absorption. Such variables make any helpful codifying of effects impossible.

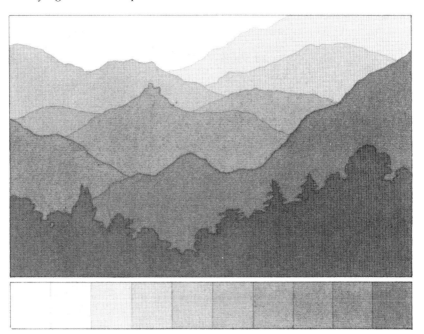

22 Lightening of tone with recession in aerial perspective

In colour plate 1, p. 66, the upper half shows the expected behaviour of colour and tone as outlined above. The bottom portion depicts the same view, but with a reversal of the usual tonal structure. A sunlit foreground set against a dark stormy sky, although not seen every day, may sometimes be appropriate in a picture to add a dramatic note.

Some authors use the term 'tonal perspective' as a synonym for 'aerial perspective'. I think that this usage is a little confusing, so I have retained the original epithet because it covers both tone and colour.

3 Eyelevel

Eyelevel may be thought of as an imaginary line at the height of your eyes, no matter what your position, which encircles you, as shown in fig. 23. Placing the eyelevel is the first task when making a perspective drawing – its position determines the appearance of all the elements of a composition.

The term 'horizon' is often used as a synonym for 'eyelevel'. I prefer to reserve 'horizon' for the straight line formed by the meeting of earth and sky, such as on a great plain or at sea (fig. 24). In these situations the horizon is visible at the eyelevel of the observer, but where hills, trees, buildings or anything else blocks the view, then the eyelevel line continues to trace the hypothetical position of the concealed horizon.

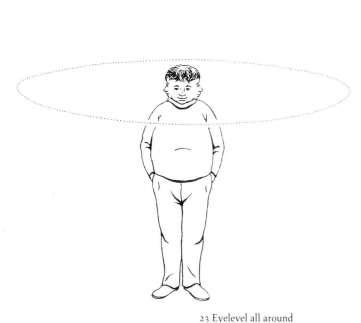

23 Eyelevel all around

24 Horizon

25 Skyline

The related term 'skyline' is also sometimes used confusingly: this properly refers to the line created by the juncture of sky and buildings etc. shown in fig. 25. Normally the eyelevel line is erased after completing a drawing, but I have retained it (dotted) in fig. 26. In this imaginary scene, the viewer sees the room as if he or she is very tall or as if there are steps at the entry. Although the appearance of everything in the sketch is influenced by the height of the eyelevel, the composition is relatively simple in perspective – elements such as the converging parallels (p. 27) of the edges of the file on the table, or the ellipses (p. 52) of the jug and glasses were straightforward.

26 Eyelevel

Where you place the eyelevel has a profound effect on the finished picture, as shown in fig. 27. In *a*, it is low, as if the observer is lying reading in the grass. The confrontation in *b* shows a 'normal' eyelevel running through the bridge of the policeman's nose. The point between the lenses also happens

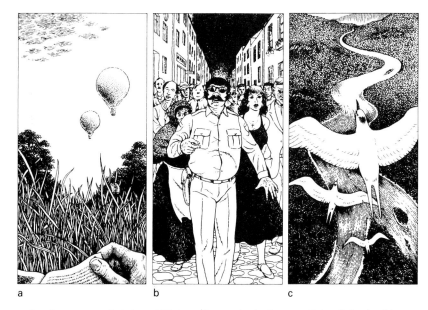

27 Eyelevels: *a* low;
b 'normal'; *c* high

a b c

to be the centre of vision, CV (p. 16) on which the parallels of the buildings
converge – reinforcing an already strong focal area. In *c* the eyelevel is high,
at the base of the distant hills; this height allows a bird's view of the forest
and river. Imagine moving the eyelevel for each of these sketches – the reader
in *a* might stand up to see a field and cows; in *b*, the officer could knock down
his addressee to provide him with a close-up of legs and cobbles; in *c* the
birds could soar to twice their present altitude, to expose a vast panorama
including desert flanked by snowy mountains.

When the subject is imaginary, positioning the eyelevel is merely a matter
of choosing a level appropriate for a given composition. In working from
nature it is sometimes difficult to be certain of the precise position of your
eyelevel. Look for pointers such as converging lines on buildings as in fig.
28*a* – horizontals define eyelevel in similar circumstances. Where no such
indicators are available, a pencil held outstretched level with the eye as in *b*,
will serve as a guide from which an eyelevel line may be projected.

28 Finding eyelevel

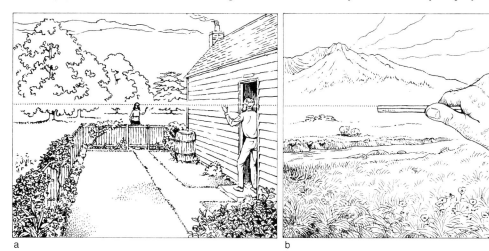

a b

4 Convergence and vanishing points

As noted earlier, convergence occurs where parallel lines recede from the observer. Before looking at this phenomenon I would like to look at the kind of situation where convergence is absent – or at most peripheral. Fig. 29 demonstrates that lines parallel to the picture plane, whether they are horizontal or vertical, do not appear to converge – though where such lines are increasingly distant from the observer they do appear to move closer together. This feature is especially noticeable in the paving in the drawing. The perspective mechanism controlling the rate of compression is shown in figs 32–34.

Though the lines in the paving do not converge, imagine now the observer turned progressively through 90° so that these lines eventually recede at right angles to the picture plane. At the beginning of the turn the apparent convergence, to left or right depending on the direction of movement, would be negligible. As the turn continued so convergence would become obvious. On completion of the movement, the observer would be confronted with the kind of perspective which is presented in fig. 30, though here a very different kind of scene is used. In this illustration convergence predominates: the observer straddles the central line which, together with all the receding parallels, moves towards the vanishing point shown as a small cross on the dotted eyelevel line. When making the drawing, I put in the lines on the roadway to emphasize convergence; they could be lane markers for different categories of people. The situation is unusual, but the perspective construction is prosaically everyday – seen in roads, corridors etc. The parallels all converge to a single vanishing point, so this form of perspective is known as one-point perspective. The three forms of linear perspective are defined on pp. 33–4; they are treated in detail in chapter 5.

In fig. 30 all the components are regular and they were straightforward to draw. In life we are just as often confronted by irregular elements which are more difficult to draw in perspective. The stone wall in fig. 31 serves as an example. The individual stones are mostly roughly rectangular, so their loose parallels appear to converge and their size diminishes in recession. I find it worthwhile when drawing such a structure to make a perspective framework first – the progression is shown in fig. 31. This method may of course be translated to other subjects – crazy paving, uneven weatherboarding, flooring, etc.

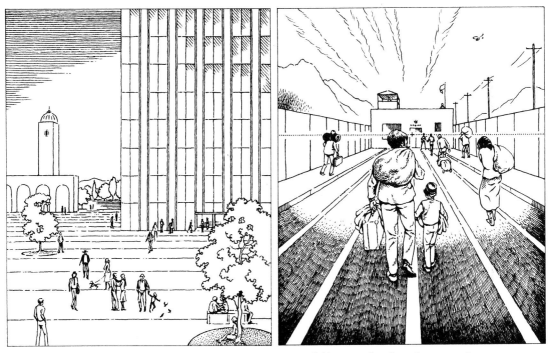

29 Parallel lines parallel to the picture plane

30 Parallel lines receding from the picture plane

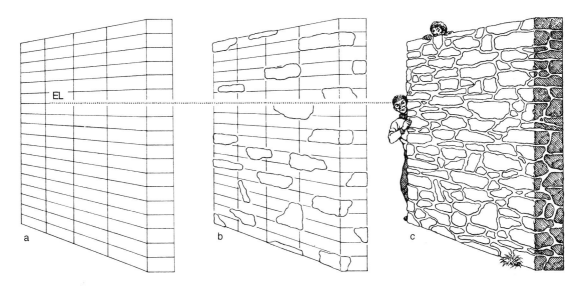

31 A wall subdivided in perspective

The initial perspective framework of the wall is shown in fig. 31a. As noted above, the first step was to decide a suitable height for the eyelevel line. Next a vertical was drawn to represent the height of the wall. Then a line was taken from the top corner of the wall to intersect the eyelevel line. This point

of intersection was the vanishing point to which all the receding lines converged. To determine the position of the vanishing point the sole decision to be made was the angle to be used for the intersecting line from the top of the wall. All the rest of the construction followed from that choice, which implied the position of the observer in relation to the wall: had the angle been steeper, the observer would have been moved to the right; a shallower angle would have meant a leftwards shift.

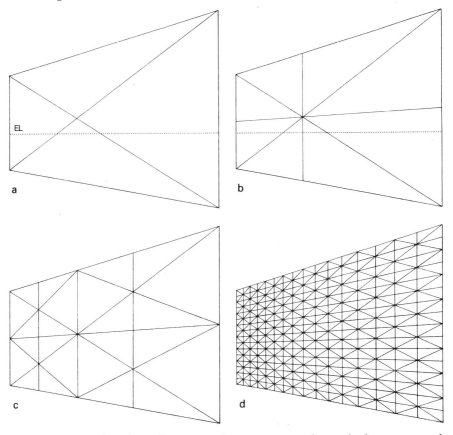

32 Subdivision of a given area in perspective

To complete the wall was easy: key stones were drawn, *b*; these were used as guides while filling in the rest at appropriate sizes, *c*.

The means of erecting the verticals in the wall in perspective is part of a fundamental and useful system of subdivision with a range of applications – it is used for various subjects throughout these pages, and it is detailed separately in fig. 32, step-by-step.

A comment about the subdivision as completed in fig. 32*d*. If the diagonals are continued towards the left, they will meet at vanishing points on a perpendicular line running through the vanishing point on the eyelevel (produced by the converging horizontals of the wall).

33 Placing variously spaced
elements in perspective

34 Regular spacing in
perspective

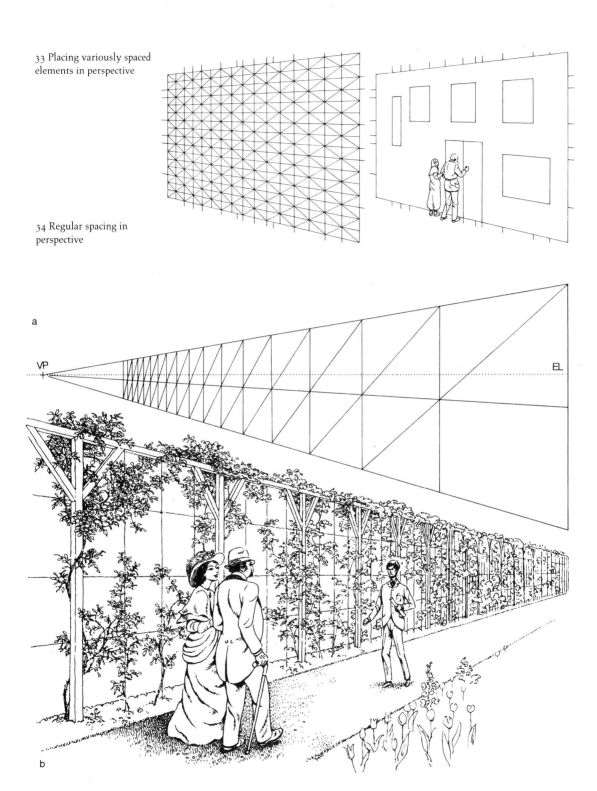

All rectangular surfaces, including squares, may be similarly subdivided, whether they are seen in perspective, face-on, or in plan. The method may not only be used for regular spacings in perspective, but also for varied spacing as shown in fig. 33. Again it usefully serves to make grids for enlarging or reducing (fig. 82).

A related procedure to the above may be used to place in perspective regularly spaced forms, such as poles, pillars etc. The method, pictured in fig. 34a, is both useful and easy to acquire. First draw an eyelevel line, EL, in an appropriate position. Next put in the first vertical unit. Run lines of convergence to intersect the EL from top and bottom of the vertical, so establishing a vanishing point, VP (the chosen angle of the first line will determine the rate of convergence as described for fig. 31). Draw a bisecting line to the VP from mid-point on the vertical. Decide on a suitable position for the second vertical. Take a diagonal from the top of the first vertical to run through the point of intersection of the second vertical and the bisecting line. The point where this diagonal meets the ground line gives the position of the third vertical. By successive diagonals continue to erect verticals for as far as you wish. One application is illustrated in b. In trying this exercise for yourself, I suggest that you imagine other settings; you may also wish to see the effect of different degrees of convergence. The same spacing method, turned through 90°, may also be used for horizontals, as in tiles etc. (pp. 57–9).

It may be helpful to point out that for added accuracy, diagonals may be taken from the bottoms of the verticals as well as the tops. Also, as noted for fig. 32d, if the diagonals are continued they will converge to meet at VPs on a perpendicular running through the VP on the eyelevel. Such vanishing points from diagonals – also termed 'distance points' – do not alter the name for the perspective in use. No matter how many such supplementary vanishing points are used, the perspective will remain 'one point', 'two point', or 'three point', according to the definitions given on p. 33. The structures in fig. 34 could have been drawn to scale using the plan system, pp. 42–3, but for nearly all freehand work the above method is sensible and far less time-consuming.

The position of a VP on an eyelevel line is decided by the position of the observer in relation to the parallel lines involved: three scenarios are illustrated in fig. 35. In each instance the VP is also the centre of vision, CV. So in a the observer is standing to the right of the picture; in b we view the picture from the centre; and in c the observer is on the left. For these examples the parallels are at right angles to the picture plane, because I wanted to show the VP within the picture area. Had the parallels been placed at a decided angle to the observer the VP would have been outside the picture (as in fig. 34b), though the CV would have remained inside. Again, through

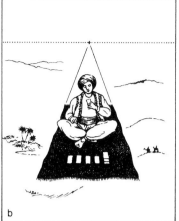

35 Different viewpoints

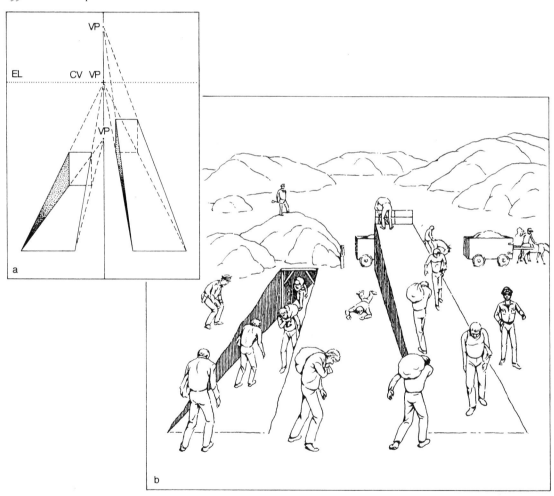

36 Inclined planes

such a change of angle two-point perspective would have become necessary (pp. 42–8).

Confusingly, even with one-point perspective, there are situations where more than one VP is used, that is, in addition to those produced from

diagonals. Parallels on descending or ascending planes give additional VPs to those on the eyelevel line derived from ground-plane parallels. In fig. 36a, VPs below and above the eyelevel come from the receding parallels of descending and ascending planes. As the parallels are at right angles to the picture plane, their VPs are sited on a perpendicular running through the centre of vision/VP on the eyelevel. The scene in b shows the way such VPs may be used. For clarity, only the mine and ramp diverge from the ground plane – in practice inclined planes may be multiple.

Sometimes vanishing points fall well outside the picture area. It is helpful to use a large working surface so that converging lines may be extended far enough for most circumstances. Occasionally it may be necessary to use parallels only marginally departing from being parallel to the picture plane – so giving a distant VP. In such instances an estimated convergence is normally sufficient.

Converging parallels and vanishing points are used in three different kinds of perspective drawing: one-point, two-point, and three-point perspective. All or any of these may be seen in a single composition. Each is defined below. Methods of construction and further exploration are given in chapter 5.

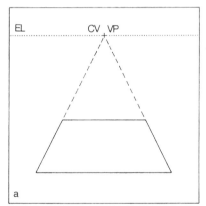

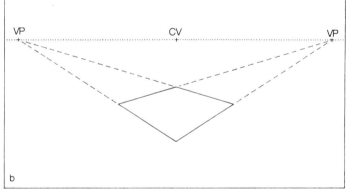

37 a One-point perspective; b two-point perspective

One-point perspective ('parallel' or 'single-point' perspective). Most of the illustrations used till now have been in one-point perspective because it is flexible enough to cover the bulk of the topics raised. One-point perspective (fig. 37a) is where parallels recede at right angles to the picture plane; the vanishing point, VP, is inevitably also the centre of vision, CV (unless the parallels are on inclines as described above). As noted at the beginning of this chapter, parallel horizontals passing through such receding parallels do not converge.

Two-point perspective ('oblique' or 'double-point' perspective). Fig. 37b, shows the simplest form of two-point perspective: a square with the observer placed immediately in front of its near corner.

38 Three-point perspective – looking up

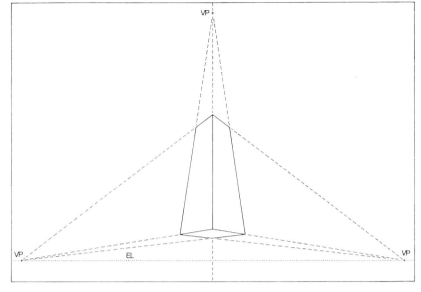

39 Three-point perspective – looking down

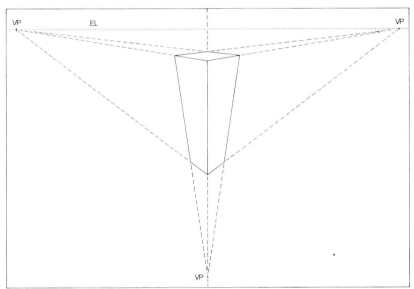

Three-point perspective. Figs 38 and 39 illustrate forms that may be interpreted in two ways: viewed through a tilted picture plane (fig. 15) or with the assumption that the forms are inclined and viewed through the normal vertical picture plane. The parallels that usually appear vertical and parallel to the picture plane recede and converge. The observer is again placed before the near corner of the form. The two diagrams are constructed in the same way, fig. 39 is simply fig. 38 turned through 180°. The recession shown is somewhat extreme because of the need to show all three vanishing points.

The colour plate on page 67 also demonstrates convergence.

5 Perspective of basic forms

Man-made structures generally consist of basic forms seen singly or together. Methods of construction for these forms are given below. These include projection from plans for use where extra precision is needed. I should stress that, for most work, plan projection is not necessary; visual estimation is usually sufficient for freehand drawing. Do not be deterred by the apparent complexity of some diagrams, in practice they are easy to follow.

Squares and rectangles in one-point perspective

Since the Renaissance, artists have used the simple and elegant way of drawing a square in one-point perspective shown in fig. 40a. Vanishing points are equidistant on both sides of the centre of vision, CV, on the eyelevel line, EL. The observer, O, is placed on the central line of vision (dropped from the CV) at a point which is at the same distance from the CV as each of the VPs. A triangle is formed by linking the VPs on left and right to O. The base line of the square is drawn anywhere within the triangle. The sides of the square are formed by lines taken to the CV/VP from each end of the base line. A diagonal is drawn from the left end of the base to the right VP, and another from the right of the base to the left VP. The position of the back edge of the square is found where the diagonals intersect the side lines. In following the exercise it is best to keep your square well inside the lines from the observer to the VPs – and so within the cone of vision (p. 15). But you may also like to try the effect of constructing squares outside these parameters.

The squares in perspective in fig. 40b, were made using the above method. The positions of the VPs and the observer are outside the diagram area in order to gain more space for the forms. Without three-dimensional vision or overlaps, the placement of the squares may be interpreted in several ways. They may be all of the same size but at different distances from the observer, or, they could be of different sizes (as suggested in the caption) and be positioned either at the same distance from the viewer, or at varying distances.

Fig. 41 illustrates how the system may be applied when drawing necessarily square objects, such as the draughtboard. The table and stools are also square, and so are the window panes. The carpet and bare room might also be thought of as echoing the form. Perspective construction of the main components is shown inset. To make the divisions on the board I used the method shown in fig. 32.

40 *a* Method of constructing a square in one-point perspective; *b* Squares of various sizes in one-point perspective

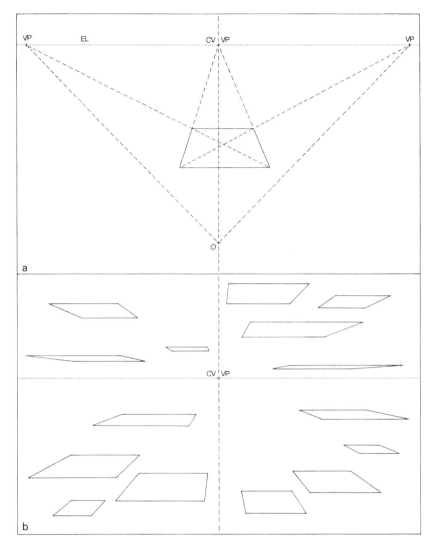

Rectangles in one-point perspective are even easier to draw. Positions for the observer and VPs for diagonals are implied, and not directly involved in construction: fig. 42*a*, shows the method. After choosing the eyelevel, I drew the base of the rectangle. The sides were connected to the CV/VP as in fig. 40*a*. Lastly, the rear edge was drawn parallel to the base line in an arbitrary position. In fig. 42*b*, I constructed a number of rectangles by this method. Usually the dimensions of such forms are decided according to context – the rectangles in fig. 43 were contrived to suit the composition. Here a large room consists entirely of rectangles in one-point perspective – notice that a high eyelevel allows an extensive view.

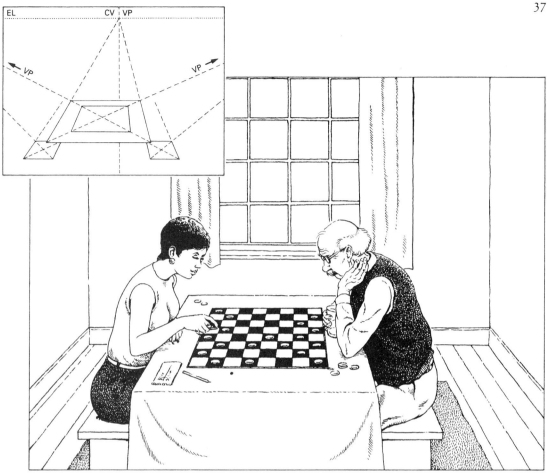

41 Composition based on squares in one-point perspective

42 *a* Rectangle construction in one-point perspective; *b* Rectangles of various sizes in one-point perspective

The rectangles were made by the method demonstrated in fig. 42. The construction was similar to that used for the square, fig. 40, except that there was no need to use VPs for diagonals because the back edge of the rectangle was a matter of choice. This contrasts with the square in 40*a* where the rear had to be placed in perspective in correct relationship to the other sides.

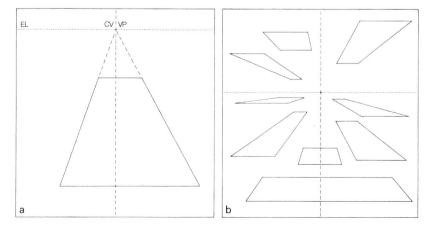

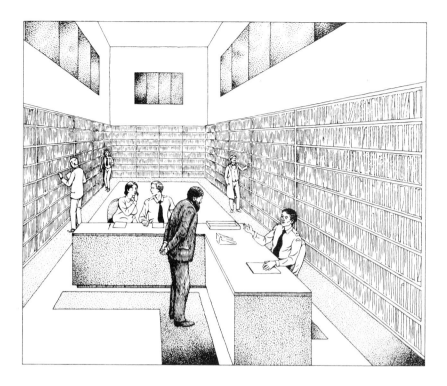

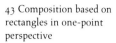

43 Composition based on rectangles in one-point perspective

Cubes and rectangular solids in one-point perspective

In figs 41 and 43, three-dimensional forms in one-point perspective were used, and I will now show how they are made. Fig. 44 shows the construction of a cube. In *a* the base was drawn, using the method illustrated in fig. 40*a*, but in this example I chose to place the CV in line with the centre of the base. In *b*, the front face of the cube was completed. I erected verticals from each end of the base line (using of course the same measure as the base) and entered the top edge. Lines were projected to the CV/VP. The finished cube is shown in *c*. Verticals were taken from the back corners of the base square to intersect the projected lines; the rest of the transparent cube was then drawn. Column *d* illustrates how the appearance of a cube alters according to its position in relation to the centre of vision. If you do a similar column, follow the sequence in *a–c*: all converging lines meet at the CV/VP, and the diagonals used in drawing the bases are projected to the VPs (not shown) on the left and right. Lack of space in the diagram precluded views of cubes placed away from the central line of vision which would partially expose the sides. In fig. 45 a cube is so positioned, constructed as described above for fig. 44, although the finished effect is different. The essential factor in exposing the side of a cube (or other rectangular solid) in one-point perspective, is to place the base line well to either side of the CV.

A cube is such a useful basic form that a model is well worth making as a reference tool. Fig. 46 shows a layout which may be reproduced at any scale you choose. Use a stiffish card and score the fold lines. Glue the tabs using paper adhesive; while it dries it is helpful to hold the structure in place with sticky tape. By moving the cube around you can confirm that perspective in a drawing conforms to reality. The markings of squares, checks and a circle

44 Cubes in one-point perspective

45 A cube arranged to expose a side in one-point perspective

46 Design for a model cube

47 *a* Construction of a
rectangular solid;
b, c applications

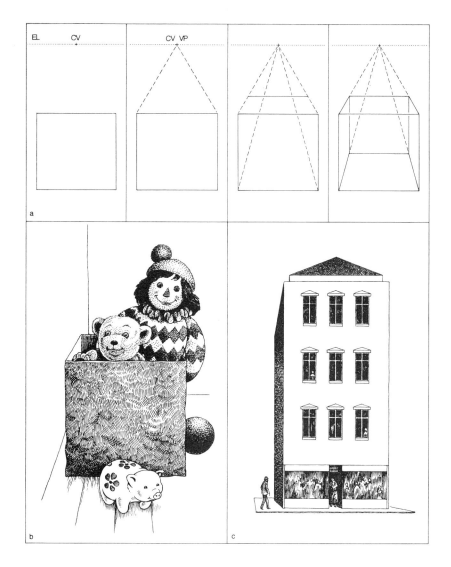

are also used in this way. Certain contexts tend to distort, for example a tiled floor may appear foreshortened to a greater or lesser degree than expected. In such instances the pattern on the model may be manoeuvred to validate your work or to reveal a flaw.

To be able to draw a cube in correct perspective should be second nature to an artist/illustrator. Yet the importance of this facility may easily be over-stressed – there are not many situations where perfect cubes are vital. You are much more likely to need to draw rectangular solids in a wide range of dimensions: building exteriors, interiors, furnishings etc.

Fig. 47 shows the construction of rectangular solids and possible applications. In *a*, the simplicity of construction is clear. (By chance I have chosen dimensions not far from those of a cube. This may usefully suggest that where precision is not essential, a cube may be convincingly drawn in one-point perspective by estimating the dimensions and the depth in fore-shortened recession.) The two applications in *b* and *c* indicate how the same

48 A simple interior in one-point perspective

basic form may be used for very different sized objects. In *c*, the building is positioned to the right of the CV, revealing the left wall. The construction is as demonstrated in *a*, but should you need help with this slightly different view refer to fig. 45.

Rectangular solids and cubes in one-point perspective also provide frameworks for interiors as can be seen in figs 41 and 43. This is dealt with more fully in chapter 7, but it is worth outlining the principle now.

Fig. 48 shows a way of setting up an interior in one-point perspective. In *a*, the eyelevel and centre of vision were decided first – here the CV is central, but any position on the EL might have been used. Lines were taken from the corners of the room to the CV/VP in *b*, and the back edge of the ceiling was placed at random. In *c*, verticals were dropped from each end of the back ceiling line to intersect the diagonals running to the CV/VP from the bottom corners of the diagram. The key lines were then inked in. In *d* the same proportions were scaled up to make a small room.

49 Views of a room in one-point perspective

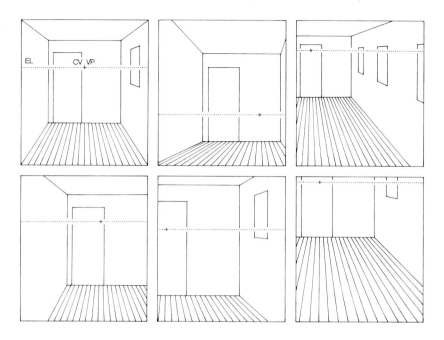

It is highly unlikely that anyone would use such a regular design except for a special purpose. Fig. 49 shows several more interesting views. More particularly it illustrates that the appearance of a room may be altered significantly by moving the position of the observer (and so the CV/VP) together with the height of the eyelevel. For comparison, the series is started by using a scaled-down version of 48d.

Squares and rectangles in two-point perspective

Placing a square in two-point perspective is slightly more difficult than for one-point perspective, fig. 40a. All the sides recede and they are fore-shortened differentially according to the position of the square in relation to the observer. As described below, usually both squares and rectangles are estimated, but occasionally greater precision is needed. Plan projection is then used, as in fig. 50. There are various methods, all time-consuming, and all resulting in cats' cradles of construction lines. As such accuracy is only needed occasionally, I shall give just a brief description of the technique.

For fig. 50, a square was drawn in plan. The position of the observer, O, was determined according to experience (experimenting will reveal the effects of different positions). Lines were drawn from O exactly parallel to the sides of the square. These gave the positions of the VPs when a line representing the base of the picture plane was inserted across them. The distance of the picture plane from the plan controlled the scale of the perspective drawing. Lines passing through the corners of the plan square were also projected from O to the picture plane together with the central line of vision.

50 A square in two-point
perspective using plan
projection

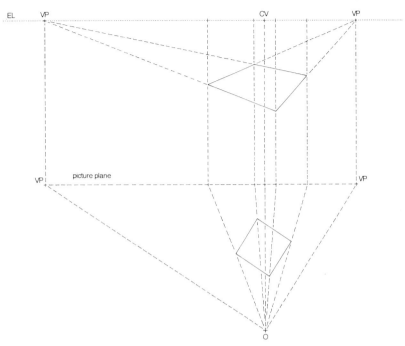

From the points of intersection with the picture plane all lines were taken as
verticals to the chosen eyelevel. The point of the near corner of the square
was placed on the projected line at an appropriate position below the eyelevel.
When this point was connected to the VPs the rest of the construction
became plain, as may be seen in the diagram.

There is a short cut for drawing an accurate square in two-point perspec-
tive, provided that the specific orientation in fig. 51 is used. In essence, a
square in single-point perspective serves as a stage in producing the two-
point version – the process is self-evident in the illustration.

51 A short-cut construction
of a square in two-point
perspective

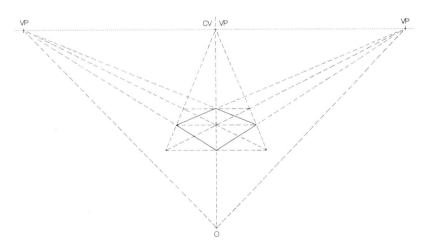

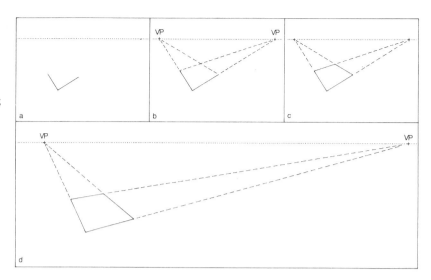

52 *a–c* Steps in constructing a square by estimation in two-point perspective.
d Effect on the position of VPs of altering the angle of the near corner of a square in perspective

Normally, instead of plan projection it is sufficient to use estimation. The steps are shown in fig. 52*a–c*.

It is evident that deciding the angle of the near corner, *a*, in relation to the eyelevel, is the prime component in determining the final appearance of the square. In *b* the lengths of the near sides were chosen, and in *c* the estimated square in two-point perspective was completed. An alternative version is shown in *d*, where the angle of the near corner was altered.

Exactly the same steps are used to draw a rectangle in two-point perspective using the precision of plan projection as for fig. 50 – except that a rectangle in plan replaces the square. Again, it is much more usual to use estimation following the method shown for the square in fig. 51*a–c*. By extending the dimensions of either pair of sides towards a VP, a rectangle is formed. The effect is shown in fig. 53*a*, with a relevant application in *b*.

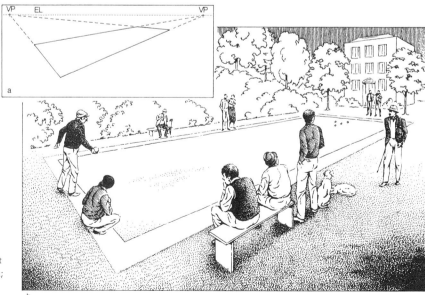

53 Rectangles in two-point perspective: *a* construction; *b* application

Cubes and rectangular solids in two-point perspective

To draw a cube in two-point perspective it is usually sensible to estimate angles and dimensions (as for the rectangular solid in fig. 58). Occasionally more precision is necessary and plan projection is then used. The cube in fig. 54 was produced by following the same process as for the square in fig. 50, except that two more steps were included in making the framework. Before the cube could be constructed within the verticals derived from the plan, I added a height line. This was done by projecting one side of the plan square to intersect the line of the picture plane; from this point a vertical was taken to the eyelevel. I then drew a ground line in an appropriate position below the eyelevel. Referring to the illustration you can see that the important near corner of the cube was established by taking a line from the left VP. It passed through the point of intersection of the height and ground lines to halt at the projected line from the near corner of the plan. To establish the height of the cube I measured the dimension of a side of the plan square on the height line from its point of intersection with the ground line. The rest of the construction may be followed from the illustration.

The orientation of the square in plan was of prime importance in determining the final appearance of the cube. This appearance is also much affected by the height of the ground line in relation to the eyelevel.

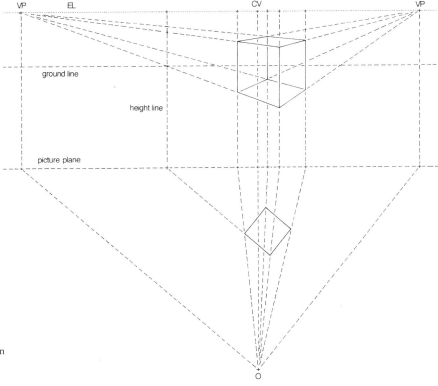

54 Construction of a cube in two-point perspective by projection

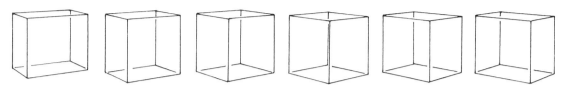

55 Cubes in two-point perspective, constructed by projection

A rectangular solid may be drawn in the same way as described above, except that the height of the form need not coincide with the lengths of any of the sides of the plan.

Fig. 55 shows six cubes all at the same angle to a base line (not included). They were drawn using plan projection to show different views as they were moved to the left or right. Although they were within a 60° cone of vision (pp. 15–17), distortion progressively increased with distance from the centre. Plan projection was also used to construct the simple room in fig. 56 in two-point perspective. A point worth noting is that to position the floorboards I could not use the straightforward system of measurement described for the one-point perspective room in fig. 48. The distances between the boards were progressively reduced in perspective by the subdivision method shown in fig. 32. Alternatively, I could have marked on the plan to be projected the positions of the boards (and also the door and window). But this step would have made the network of construction lines too complex.

Another example of a form based upon a cube drawn in two-point perspective is shown in fig. 57. The internal divisions were made by the method

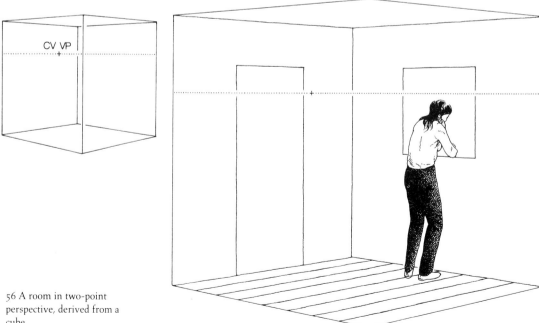

56 A room in two-point perspective, derived from a cube

57 A form based on a
cube in two-point
perspective

shown in fig. 32. Such divisions are in proportion to the main form – so as,
here, each face is a square in perspective, all the subdivisions represent
smaller squares. The openings vary from single to several square units.

Rectangular solids, including cubes, are much easier to handle in two-
point perspective by estimation rather than by plan projection. The process
is much the same as that detailed earlier for squares and rectangles, with the
added slight complication of height. A sequence of construction is shown in
fig. 58a. After deciding the position of the eyelevel, the angle of the near
corner is again the key element since this is the way to establish the vanish-
ing points. From this first step the sequence may be varied according to your
choice. I have put in a line to indicate the height of the object, but it would
have been equally appropriate to have preceded this by choosing dimensions
of depth and length to complete the base before moving on to three dimen-
sions. You may like to experiment in this respect. To accommodate the VPs

48

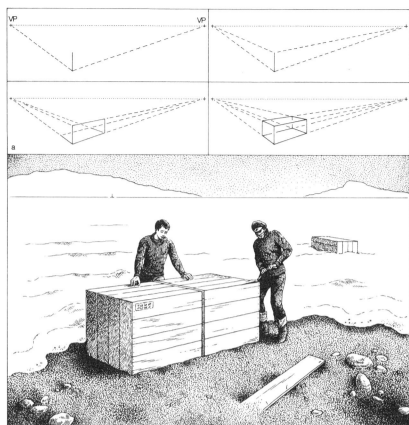

58 *a* Construction by estimation of a rectangular solid; *b* application

59 The near corner of right-angled solids – the final three examples are factually impossible

Cubes and rectangular solids in three-point perspective

within the framework, the near angle is rather acute so that convergence is fractionally too marked. This is remedied in fig. 58*b* where the crate on the beach has VPs relatively further apart. The crate in the background is in one-point perspective. The position of the centre of vision was estimated – its position is indicated by the tiny boat on the eye level/horizon line. The CV was of some help in working on the figures.

There is a particular error often seen in two-point perspective. In fig. 59 the near corner of a right-angled body is viewed from immediately in front at a number of levels. At the top, the base is just below the eyelevel line, then I placed the near corner progressively lower and so it became more acute. The error is shown in the three lowest examples, which are well outside the limits of the cone of vision. In these the angle is clearly more acute than a right angle. This is an impossibility in reality. You may care to test this assertion by using a box or the model cube (fig. 46).

As noted earlier (p. 34), to see objects in three-point perspective it is necessary for the form involved to be viewed either through a tilted picture plane, or for the object itself to be sloped so that all parallels converge.

After the preceding discussion of two-point perspective, I think that the constructions in figs 38 and 39 are almost self-explanatory. The procedure is just as for two-point perspective, except that you have to decide the degree

of convergence of the verticals as they recede up or down. As can be seen in the illustrations, the verticals converge to meet on a perpendicular line which runs through the centre of vision. The position of the CV is not on the eyelevel if the three-point perspective results from a tilted picture plane – as in fig. 15. The CV will be on the eyelevel line if the object and not the picture plane is sloped towards or away from the observer. In each instance, the positioning of the CV itself is of little consequence in the construction, but the perpendicular line running through it – the central line of vision – is important. The placement of this line is a matter of choice when using estimation, as also is the position of the VP along it for the receding verticals. Applications of three-point perspective are shown in fig. 60. To aid

60 Three-point perspective in application

clarity, I have used simple rectangular solids without much elaboration. You may like to project the receding and converging parallels in order to analyse the construction. It is worth noting that an exaggeration of upwards or downwards convergence enhances dramatic quality.

So far the forms shown in three-point perspective have had verticals which may be interpreted either as sloping towards or away from the observer, or as being at right angles to the ground plane with the picture plane tilted. A further possibility is illustrated in fig. 61: a rectangular solid is shown tilted to the right as well as being slanted towards the observer. I drew this illustration using the same steps as in fig. 39, except that a tilted line (shown in the insert) supplanted the natural eyelevel line.

Drawings in three-point perspective may also be made using more complete methods, including plan projection, but for nearly all illustrative or artistic purposes estimation is sensible.

61 Tilted rectangular solid in three-point perspective

Circles and ellipses A circle in perspective becomes an ellipse. Ellipses may be drawn by the confident wholly by eye; those less sure can put in a guiding framework, as

illustrated in fig. 62. As a circle may be fitted within a square, so it is necessary to ensure that the frame in perspective is derived from a true square. The one in *d* was drawn by the method shown in fig. 40*a*. It is helpful to subdivide the square before drawing the ellipse (see fig. 32). In fig. 62 this subdivision is taken only to an early stage to avoid too many construction lines in the illustration. In practice you may find it useful to carry the process further. Notice that, because of foreshortening, the widest part of the ellipse, shown by a broken line, is in front of the true centre line. Also, by using the model cube (fig. 46), you will notice that when viewing a circle from a given position, its appearance will remain constant no matter how the enclosing square is rotated in a single plane. This shows that where a circle appears within a square presented in two-point perspective – as perhaps in a tiled floor – the circle will be formed in the same way as in the one-point perspective view seen from the same position.

62 Circles in perspective

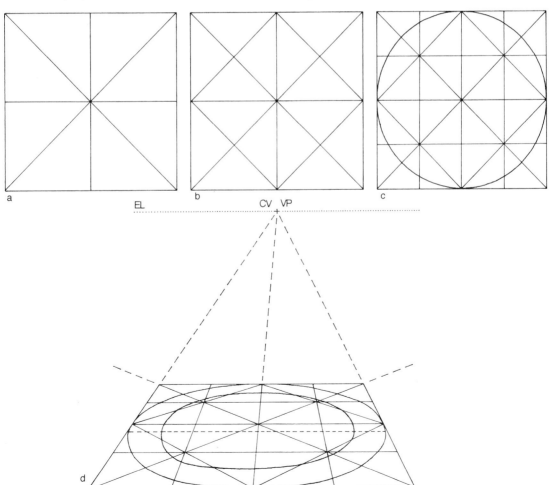

To draw perfect ellipses mechanical aids are available in the form of templates etc. I have not used such devices for the illustrations in this book, and you will probably be able to see slight irregularities and flaws.

In an opaque object sometimes only the forepart of an ellipse is visible. For accuracy it is worthwhile sketching the whole ellipse before fining up the visible portion.

63 Ellipses in perspective

Fig. 63 shows a common situation in which ellipses are numerous.

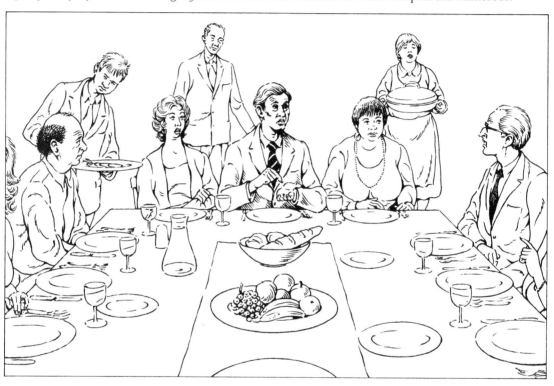

Cylinders and spheres

Fig. 64 illustrates a cylinder analysed as a series of ellipses. The range included exceeds the extent of the normal cone of vision by at least the outer pair of ellipses, but it seemed worth extending in this hypothetical example. I drew a number of squares in one-point perspective and used the construction indicated at the top and bottom throughout. Notice that the outer edge of the form connects the widest part of each ellipse (shown by a broken line in fig. 62d) rather than the geometric maximum width.

In fig. 65 a cylinder is orientated in two-point perspective. For this example a rectangular solid with square ends was drawn through plan projection (pp. 42–3) – for most uses a freehand estimation would be suitable. Then the key construction lines were inked and the main axis was represented by a dashed line.

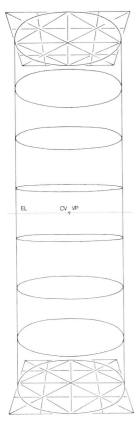

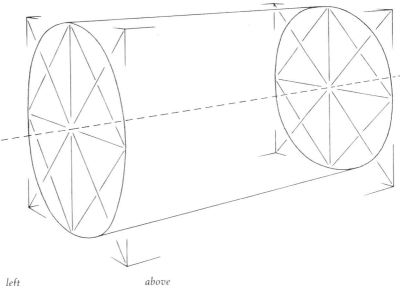

left
64 Construction of a
cylinder in one-point
perspective

above
65 Construction of a
cylinder in two-pooint
perspective

A bottle, fig. 66, exhibits the cylindrical form together with numerous
ellipses which were drawn using the same steps as in fig. 64.

The sphere in perspective provides a paradox: in reality, no matter where
a sphere is positioned in relation to the eye, it retains its form without dis-
tortion – and so it may be shown in any composition (fig. 67). Yet if a sphere

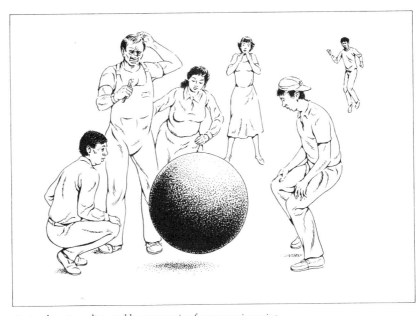

66 Cylinder and ellipses

67 A sphere is undistorted by perspective from any viewpoint

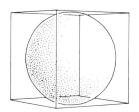

68 Perspective distortion of a sphere within a cube as the outer edge of a 60° cone of vision is approached

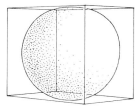

is enclosed within a cube, distortion becomes progressively greater as the bounds of the cone of vision are approached, as in fig. 68. This illustration is intended to demonstrate the phenomenon – though it has to be admitted that spheres inside cubes are scarcely everyday subjects. In the illustration, made using plan projection, the sphere above was drawn to straddle the central line of vision. The form below was placed not far from the edge of the conventional 60° cone of vision. As well as serving the above purpose, the distortion of both sphere and cube suggests that 60° is too wide an angle invariably to provide convincing images. This diagram and others, e.g. fig. 55, confirm that the 40° angle that I generally use is preferable.

Triangles and triangular prisms

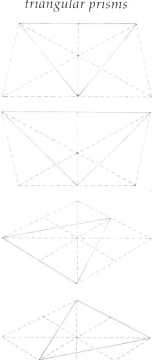

Triangles are featured in fig. 69. Each triangle is shown constructed inside a square drawn either by one- or two-point perspective using the means shown in fig. 40a, and fig. 51. (Proportions could have been altered easily had rectangles been used rather than squares. Also, you might prefer to use estimation in constructing the frame.)

In fig. 70, further subdivision using the method detailed in fig. 32 allows a greater variety to be produced – the forms in *b* are all derived from the framework *a* by connecting selected points. It is curious that in the arbitrary disposition of the triangles in *b*, the mind struggles to introduce a three-dimensional interpretation – this might have been enhanced by judicious shading.

An intentional representation of triangular solids or prisms is given in fig. 71. The one- and two-point perspective frameworks in fig. 69 were used in the process. For each form a triangle was established on the ground plane. Then I erected a vertical from a point selected with the finished effect in mind. Finally, lines from the corners of the triangle were taken to the top of the vertical. The vertical in the left-hand form remains as an example; I erased the rest.

A cube may be used as a stage in drawing much more complicated prisms involving triangles. Unfortunately, such constructions require a tangle of lines almost impossible to follow, especially when an illustration is reduced in reproduction. For this reason only the simple pyramid, fig. 72, is included

69 Triangles in one- and two-point perspective

70 Triangles derived from a subdivided square in one-point perspective

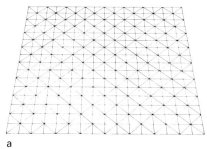

a

b

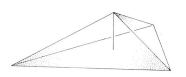
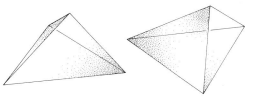

71 Triangular prisms

here. After producing a cube by plan projection the pyramid was drawn by connecting the four corners at the base to the central point of the top.

Fig. 73 shows a composition using triangles and prisms with triangular facets – from the opening in the wall with a patterned cloth draped over the sill, to an array of forms in the foreground.

right
72 Construction of a pyramid

far right
73 Triangles and triangular solids

Polygons and polygonal solids

Multi-sided figures only feature in passing here, because they involve complexities best reserved for specialist technical works.

In developing polygonal forms both cubes and cylinders may be used for the initial phases. An example is shown in fig. 74 where an octagonal solid is derived from a cube. In this instance the cube in fig. 72 was repeated. For clarity the first steps are shown on a plan view of one face of the cube, subdivided as shown. I entered two concentric circles on the plan, and the subdivision enabled me to plot the positions of the eight corners of an octagon. These points and the inner circle were transferred to the opposite face of the cube subdivided in the same way, though to a lesser extent because in the finished work the inner circle would not be visible. Connecting the relevant points gave the sides of the octagonal form.

The completed solid is represented as a piece of minimal sculpture – though several other functions were not hard to imagine. The octagonal form might also be modified as required in various ways while using the same subdivision framework, e.g. the sides might be fluted by introducing shallow scallops in perspective.

74 An octagonal solid

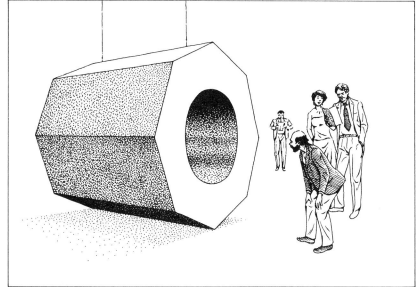

75 Basic forms and the human figure

This type of form is relatively easy to construct, but polygonal solids with same-sized facets (other than cubes) present difficulties that are not worth pursuing here. For most readers the practical value would be virtually non-existent.

Basic forms are sometimes represented as being helpful in drawing people; but although the torso and limbs are loosely cylindrical, this concept does little to reflect the elegant and variable subtleties of the body, fig. 75. More advice about drawing figures is given in chapter 10.

6 Perspective of repeated forms

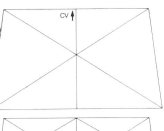

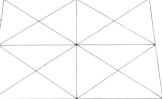

76 A square floor in one-point perspective using square tiles

Repeated forms are familiar in tiled floors and walls, pillars, arches, stairs etc., and their treatment in perspective is generally straightforward and effective.

A surface that is tiled or is patterned in a similar way may be realized through using subdivision by diagonals (fig. 32). A common situation is shown in fig. 76 where a tiled square floor is constructed in one-point perspective. The floor was first drawn in outline by the method shown in fig. 40. In order that the tiles should not appear overly compressed by foreshortening, the eyelevel was placed unusually high. In fig. 76 steps in subdivision by diagonals are shown, and in the final stage the tile pattern is exposed because the construction lines have been removed. For the application shown in fig. 77, the same design was scaled up and the man added. I then decided that the tiles appeared too small in relation to the man so their size was doubled (i.e. the area of each was quadrupled). By a process of trial and error, I placed the figure to suit the slightly awkward high eyelevel.

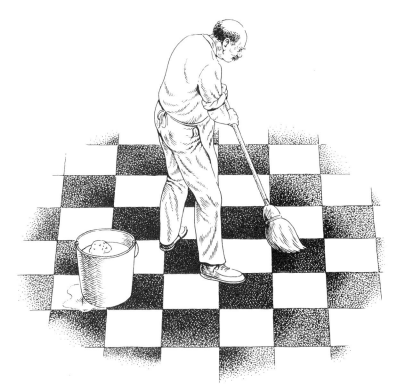

77 Square tiles in one-point perspective

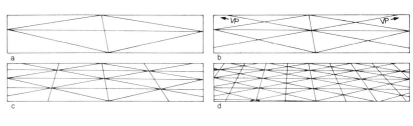

78 Subdividing an area in two-point perspective

79 A floor in two-point perspective using square tiles

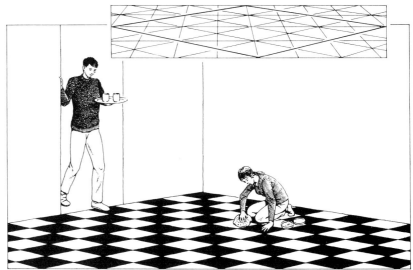

A similar floor, this time in two-point perspective, is shown in fig. 78 as a stage towards the application in fig. 79. I adopted the form used earlier in fig. 56. It is often appropriate to use previously drawn perspective constructions for other purposes – though you should also bear in mind the need for variety. In this connection the use of perspective grids is sometimes helpful, these are featured on pages 80–86. Fig. 78a shows the floor area with diagonals. In b the square was quartered – to add these lines I had to project the parallels of the major square to their VPs, in order to find the correct angles for the quartering lines. From this point it was possible to continue the subdivision without further reference to the VPs, though for accuracy it is usually advisable to continue to project parallels to them. Notice that a third VP is located by the 'vertical' lines; also the construction lines are extended to fill the rectangles.

The final step, in fig. 78d, is repeated inset in fig. 79, with the original square in two-point perspective emphasized. This same construction was followed in the chequered floor.

The above way of drawing a tiled floor may be used to yield quite different effects. Some possibilities are shown in fig. 80 in one-point perspective (two-point perspective would have been equally appropriate). For each floor area the pattern was halted before completion so that the construction remains visible. Even in such small areas as those in the illustration there is considerable scope to create designs. Further possibilities would occur by increasing the size and by introducing colour as well as variations in tone.

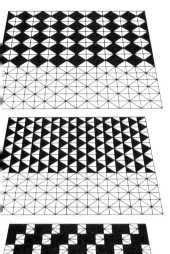

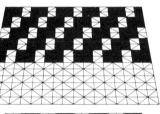

Up to this point, areas have been drawn by using the now familiar geometric method of subdivision by diagonals. You are probably well aware that this method inevitably means that the number of units, tiles etc., within a given area (square or rectangle) will always be a multiple of 4. This inbuilt parameter may not always produce a balanced pattern – as may be seen in the last example shown in fig. 80. There the effect would have been much enhanced by an extra row of black tiles along the left border.

Fig. 81 shows a partly arithmetical means of obtaining desired balance while using one-point perspective. Construction is shown in stages. Step *a* includes just a baseline, and sides which converge to a CV/VP high above (not shown). In *b*, the baseline was divided mathematically into 15 units (avoiding a multiple of 4). Lines from these divisions were projected to the CV/VP. Next, the depth of the first row of tiles was estimated – for this partly arithmetic system estimation of the first depth dimension is always neces- sary (unless the alternative of plan projection is used, in which case all the tile divisions may be entered on a plan before projection in perspective). The diagonals were then taken to intersect the eyelevel, so establishing VPs on each side. These diagonals were produced by taking lines from the lower corners of the main area, through the intersections of the first (estimated) depth line of the tiles with the lines running to the CV/VP. The twin diagonals also established the far edge of the area – which may or may not be a square, depending upon the relation of the depth of the first row of tiles to the whole. If the first row of tiles happens to be squares in perspective, then the whole area will be, through projection of the diagonals. Should the first row of tiles be rectangles, then in a similar way this will be reflected

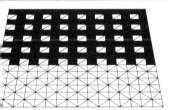

80 Tile patterns on floor areas produced through sub- division by diagonals

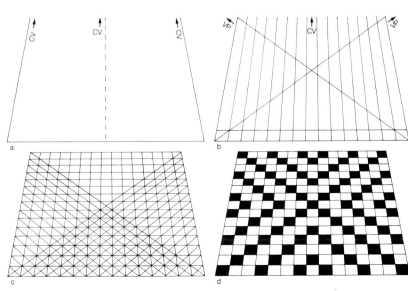

81 Floor area divided partly arithmetically

in the larger area. In *c,* subdivision was completed by continuing to run diagonals to the VPs. Where the diagonals intersect you can place the horizontals in perspective. These intersections progressively diminish in number, but provided the drawing has been precise the remainder provide a sufficient guide. If you prefer, more intersections may be made by extending the baseline on each side and measuring more divisions – so giving more diagonals. In *d,* the construction lines have been erased to expose the tiled surface. A regular pattern was blocked in – I unintentionally created an optical illusion which suggests a bulging centre.

This is a suitable place to digress briefly to introduce the grid as a method of scaling drawings up or down. Its use is demonstrated in fig. 82 where the process is almost self-evident. In *a* a square grid is constructed over the design just as for the square tiled floors above. The grid was proportionately

82 Changing scale by using grids

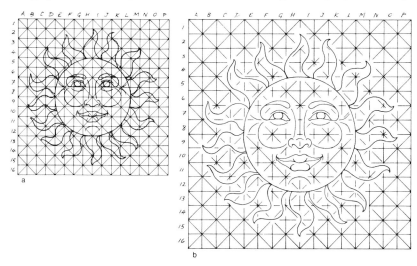

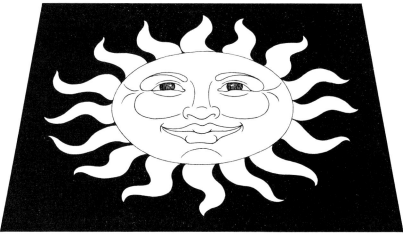

enlarged in *b*, and the design transferred by following its lines through each grid square. As an aid to accuracy, I labelled the units along the main axes. I stopped the construction lines short of the design when inking, in an attempt to make the sun stand out rather better from the surround – in practice these lines would be continuous. In *c* the form used for the squares in perspective in fig. 80 was enlarged. I created the guiding grid as before and then drew the sun over the foreshortened area. With a high eyelevel, as in fig. 82, the process is easy because perspective distortion is not great. As the eyelevel is lowered, forms in perspective become subject to progressively greater distortion through foreshortening. Following the proportionally altered lines of the design therefore becomes more challenging. If you have access to a photocopier which can enlarge and reduce, you can use it for the step from *a* to *b*, before moving to *c*.

Returning to repeated forms, fig. 83 illustrates pillars and arches. In *a*, the method for spacing elements regularly in perspective is recapitulated (described on p. 31, fig. 34). Below, in *b*, I have reproduced this spacing in pillars topped by arches on a two-point perspective form. I used a certain amount of estimation for this drawing once the guiding framework of the pillars was fixed: I did the spacing of the railings and the upper windows in this way. In *c*, a simple combination of pillars and arch is detailed in one-point perspective. The structure was started with the two squares forming the bases. The axes of the columns were fixed by the intersection of the diagonals of these squares. The square capitals at the tops of the axes are slightly smaller than the lower ones – so giving the conventional tapered appearance. For clarity I have drawn the most basic construction – this may be easily interpreted in two-point perspective and elaborated as required.

Another repeated form is shown in the windows in fig. 84. I needed a rather more developed framework than for the preceding illustration, so I used the method introduced earlier, in fig. 33. The construction in *a* was repeated, enlarged in proportion, in *b*. The widths, heights, internal divisions and spacing of the window frames were drawn just as indicated in *a*. The position of the VP on the right (used in construction) is defined by the converging lines. A second VP, placed by estimation on the left, was necessary to deal with the thickness of the wall around the frames: lines were taken from the second VP to run through the four corners of the left frame. By deciding the wall thickness along the line running through the top right corner of the frame it became possible to show the wall surround through using both VPs. Notice that by projecting the wall thickness forward from the near edge of the window, a portion of the pane is obscured. This covered part becomes progressively greater with distance. The full narrow box-like structure of the window surrounds is seen only in the construction phase. To keep the drawing uncomplicated, the windows have sliding panes.

83 Pillars and arches

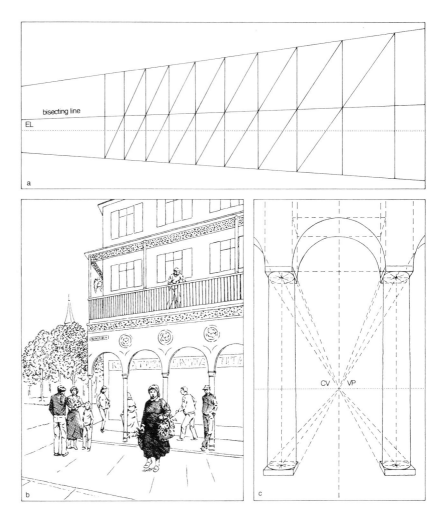

Stairs are made up of repeated forms, and they may present difficulties until the structure is understood. In fig. 85*a*, the construction of stairs in one-point perspective is seen from directly in front. After the eyelevel was chosen, the CV and the central line of vision were entered. Once I had decided the length of the first step and its height in relation to the EL it meant the first riser could be drawn as a long rectangle. The inclined plane of the stairs (see also fig. 36), once selected, was projected in lines from the top and bottom of the first riser to a VP high on the central line of vision. These lines imposed the breadth of the first tread, and all the subsequent ones as their lines were projected to the CV/VP (which is not labelled in this illustration because I wanted to leave the construction lines clear). Once the initial choices had been made, the rest of the work was easy and the staircase might have been continued until it became impractical to go on. For *b* I used the same construction except that some of the upper steps were omitted in order to include the door and a section of ceiling. Fig. 86 depicts two more views of stairs. For

84 Repeated windows

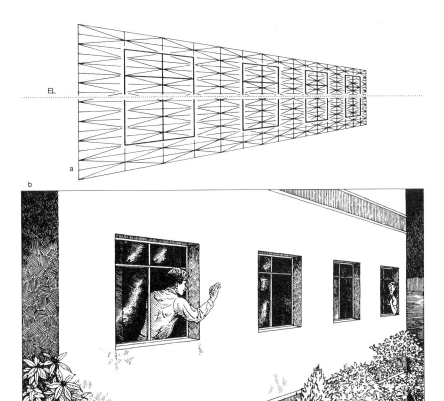

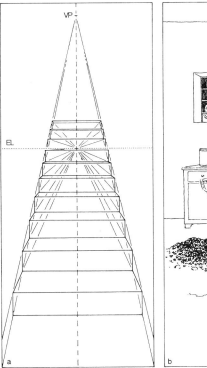

85 Stairs in one-point
perspective from the front

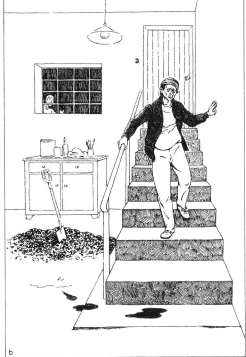

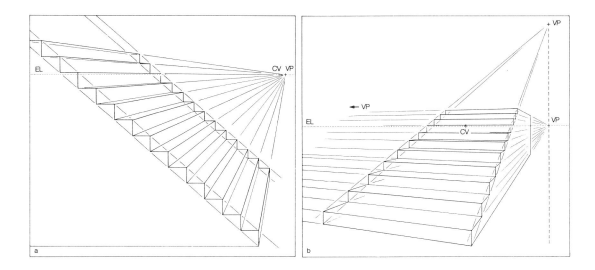

EL

CV VP
+

a

+ VP

← VP

EL

CV
+

VP

b

86 *a* Stairs in one-point
perspective seen from one
side; *b* Stairs in two-point
perspective

a, the stairs are seen from one side in one-point perspective. The construction was straightforward once the height of the EL was chosen together with the position of the CV/VP. The line of the base was placed parallel with the border of the diagram. The height of the first riser was entered, and then the near edge parallel lines of slope. Drawing the stairs in section was then possible – each riser a vertical and each tread parallel to the baseline. From the zig-zag line of the stairs, lines were projected to the CV/VP. This allowed the insertion of the second pair of sloped parallels in which the further edge of the structure was drawn. Since this construction was made in one-point perspective, the verticals and horizontals parallel to the picture plane do not converge (see p. 27).

In *b*, the stairs were placed in two-point perspective. The near angle of the base, with its relation to the EL, was poached from an earlier plan-projected form – so enabling the CV to be correctly positioned. (Again, the near angle could appropriately have been assessed by eye if wished.) From this near angle, I projected lines to intersect the EL to left and right, giving the two VPs. After deciding the slope of the stairs together with the height of the first riser, I was able to take twin converging parallels to meet on a vertical running through the VP on the right. The edges of the risers and treads were established as before. Though the right VP fell well within the diagram area, the left VP required the use of a long ruler.

Another situation is seen in fig. 87. I wanted to show stairs viewed from above, in this instance a gangway. Construction is shown in *a* where the chosen slope means that the converging parallels meet well above and outside the diagram area. The detail of the individual treads and risers is easiest to follow in the larger forms at the head of the stairway. The method used was that of the earlier examples. As the edges of the treads were parallel to the down-facing picture plane they do not converge. In contrast, the edges of the risers move away from the picture plane and so they converge to a VP below the illustration. The outlines of the stanchions may be followed to the same VP. In *b*, the man is leaning backwards slightly prior to taking the next step.

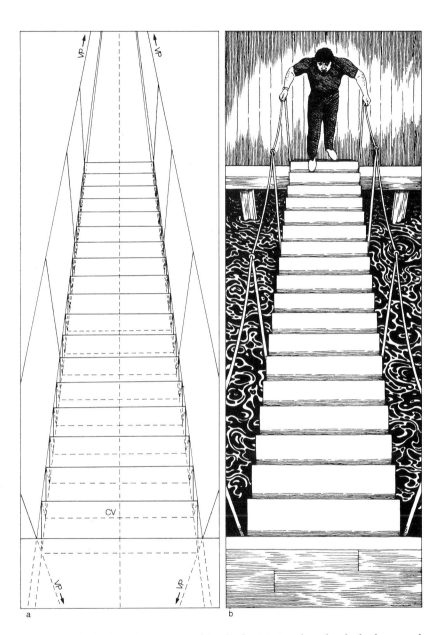

87 Stairs in one-point
perspective from above:
a construction; *b* application

I estimated the foreshortening of his body. Notice that the deck above and
the planks below, being parallel to the picture plane, show no convergence.

You will be able to think of other repeated forms. The information given
above should suggest how to draw them.

Plate 1 Aerial perspective: *above* usual values; *below* reversal

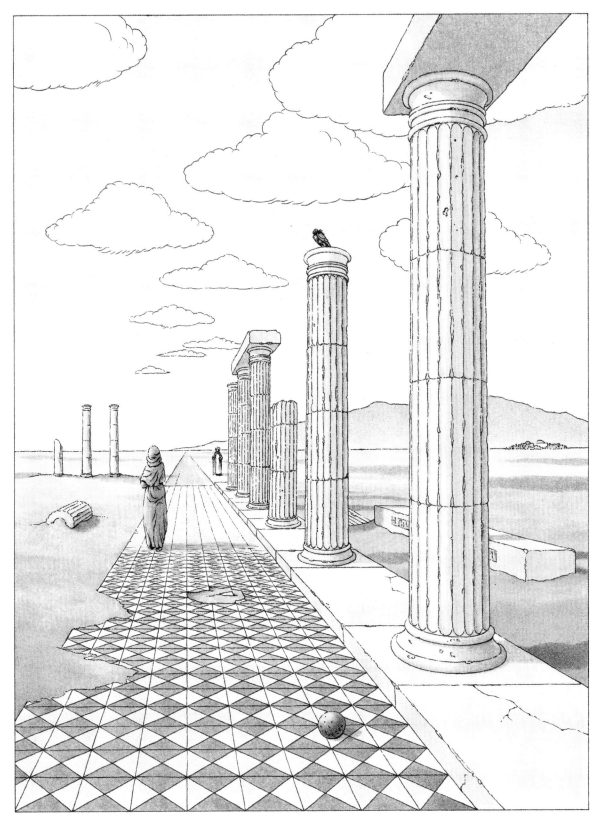

Plate 2 Convergence

7 Buildings

In this chapter, the exteriors and interiors of buildings are explored, working from basic to complex forms in perspective. As noted earlier, in portraying a scene from life, attention to perspective is a matter of following what you see with an awareness of your eyelevel, disposition of vanishing points etc. But there will be times when you wish to reinterpret material from your sketchbooks, perhaps using greater detail, or perhaps changing the orientation of subject matter – including buildings – to suit a particular composition. It is then that a confident use of perspective knowledge is especially helpful. Artists and illustrators working largely from their imaginations find buildings sometimes rather testing – exteriors and interiors treated realistically require thought about correct perspective.

Exteriors

The simplest building exterior may be taken as a basic box shape, as drawn in fig. 88*a*. Usually, I would sketch such a form by eye, but this one was plan projected (fig. 54) so that I could be precise in discussing dimensions.

Whether you are using sketchbook originals, holiday snaps, your imagination, or a mixture of sources – if your results are to be convincing you should be careful about the size relationships of the components. This is especially so where figures are introduced as in fig. 88. In the plan, drawn to scale, I decided that the base of the building should be 4.5 m long and 3.4 m deep. The outline for the bottom of the primitive veranda was just over 1 m wide, running the length of the building. Using a height line in relation to the EL, see fig. 54, the flat top was established at 3 m, and the height of the windows and door were also fixed as seen in *b*. I chose to place the eyelevel of the observer as if the one-room building were on flat ground in relation to the viewer.

In the lower section of the illustration the form in *b* was slightly enlarged using the grid system (fig. 82) and I began the enjoyable process of elaboration. My first thought of level ground did not work well so I made the foreground fall away, adding two steps to emphasize the slope. This suggests that the observer is standing upon a slight rise off the path, which appears to twist away to the right. As work progresses on a composition, the introduction of any element carries a burden of implication. From this sketch you might deduce the rough latitude, something of the climate, the season and so on. Though the building might well have been set in any of several countries, it would not have been difficult to have fixed the area by, for instance, including particular vegetation – perhaps a saguaro cactus. Again, though the dress

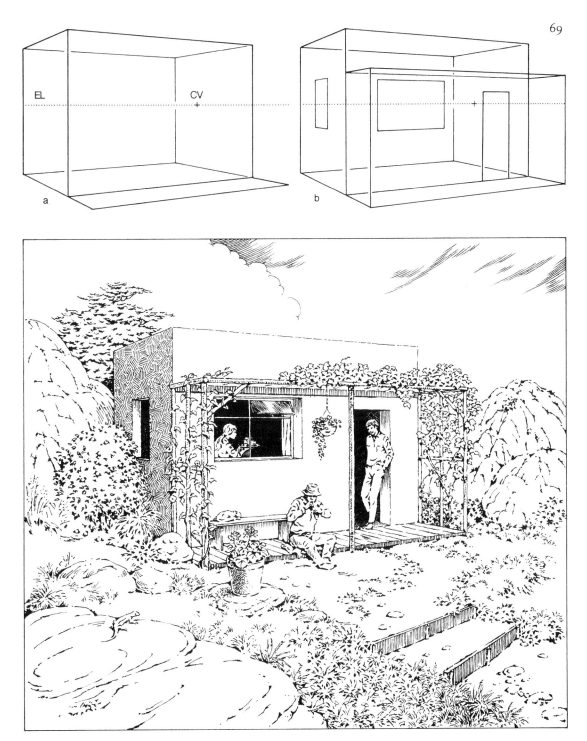

88 Development of a simple building in two-point perspective

looks more or less that of today, a television aerial or something similar would identify the period more clearly. The time of day could have been indicated by shadows etc. Though you may be primarily concerned with such artistic considerations as form, colour, tone, light and so on, with every stroke the possibilities of interpretation increase.

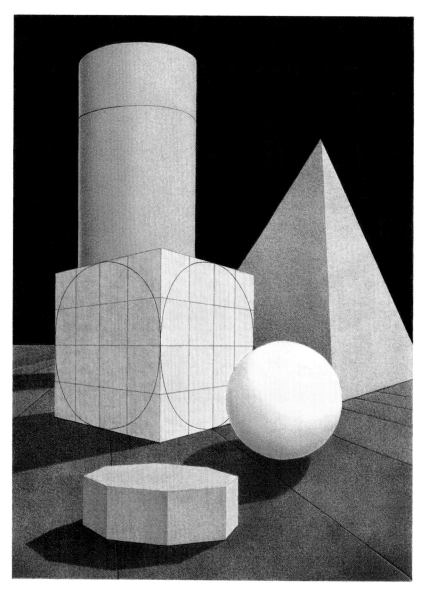

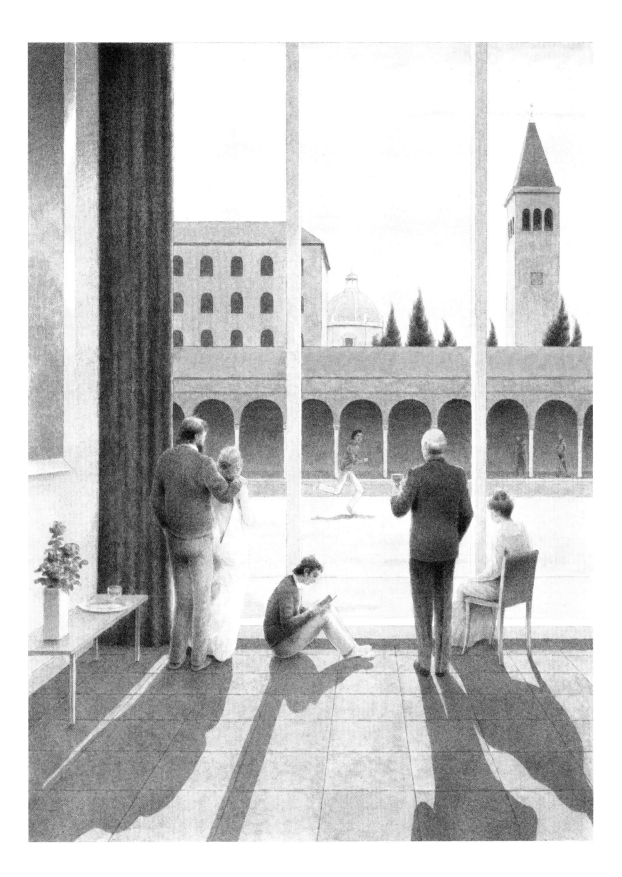

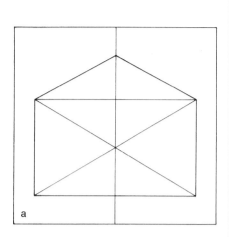
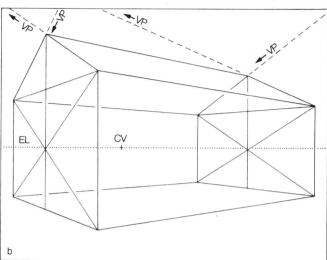

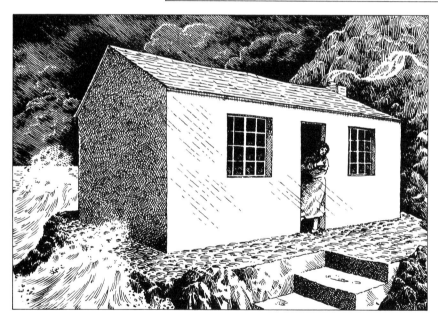

89 A roof in perspective

In fig. 89 a sloped roof is added – again using two-point perspective. In *a*, placing the roof apex correctly at mid-point is shown. Then *b* shows how the principle works in perspective. Notice the receding parallels converging from the roof edges. Finally, the finished drawing shows a single-storey cottage huddled against a cliff.

A dormer window in perspective can be difficult to do. The basic shape used in fig. 90*a* is a cube topped by a gable. The ridge of the gable was positioned in the same way as in fig. 89. This is straightforward but for the

junction of the gable roof with the main roof – this portion is seen in the form of a small triangle that unites the gable roof with the main slope. The angle of the main roof is given by dashed lines on the sides of the cube. These lines, and the line of the edge of the roof on the right, all converge to a VP well above. The completed dormer window is pictured in *b* where the construction above has been transferred and detailed. The girl and birds were added to give interest and a sense of scale.

90 A dormer window

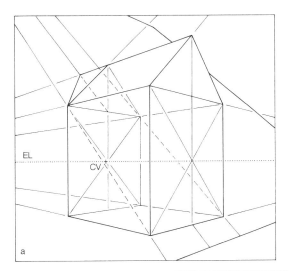

Plate 5 Reflections using two mirrors (see p. 97)

Plate 6 Shadow on wall

For many artists, studies of buildings on their own are satisfying, which is understandable given the subtle interplay of forms which reflect centuries of architectural history. Once you have managed to draw with confidence a basic roofed building, with and without dormers, you are equipped to portray the many developments from this essential form. Ornamentation and detail may be quite demanding, but usually it is not necessary to follow every line – an impression is often enough.

Occasionally buildings depart far from the familiar rectangular solid (and its various combinations). Except for radical exceptions, which might be typified by the Sydney Opera House, such departures are usually analysed in terms of the basic forms discussed in chapter 5. One of the commonest alternative forms is that of the cylinder, expressed as a tower, dovecote, lighthouse, windmill etc. Cylindrical constructions may also be attached to other forms – as in a castle, or perhaps a turreted neo-Gothic confection. A simple round tower is illustrated in fig. 91. A cylinder (p. 53) tapering slightly upwards is shown in *a*. The eyelevel was set at about the normal height in relation to a projected door. In *b*, a completed tower is featured with battlements added above the top ellipse. A door, window slit and signs of missile damage were added together with an impression of stonework. The line of the stones follow a series of sketched-in ellipses placed in relation to those established accurately in *a*. These emphasize the cylindrical form, rather than using shading for that purpose.

91 A tower in one-point perspective

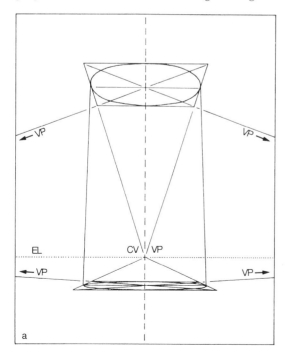

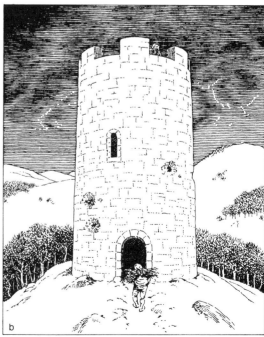

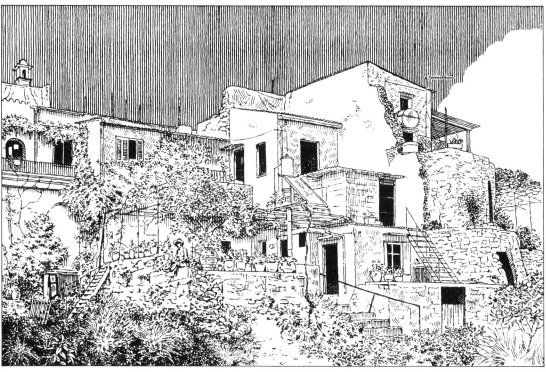

92 A group of buildings in
two-point perspective

So far buildings have been drawn in isolation, but in fig. 92 a number are shown together in two-point perspective. I chose a scene that intrigued me in Crete. An indeterminate number of units, randomly built over a long period, now give the sense of an organic whole. The setting was in reality colourful and attractive, with the typical Mediterranean elements of blue sky, flowers and terracotta tiles. Though all the receding parallels converge to their VPs on each side, the situation is confused by the shallow inclines of the roofs and uneven terraces. The small dwellings nestle against the massive remains of ancient Venetian city walls. The pattern created by the dark windows and doors was emphasized to give the composition coherence.

Interiors

Simple interiors were drawn earlier, in figs 48 and 49, when discussing rectangular solids and cubes. This theme is now expanded. In fig. 93a, I constructed an interior in one-point perspective with the centre of vision outside the image area, which exposed a sizeable expanse of wall. By placing the observer at a suitable distance the scene remained within the cone of vision and distortion was avoided. The stairs were made as described for fig. 85, and the flagstones were drawn using the method shown in fig. 76 (except that the depth of the initial row was arbitrarily chosen starting from below the border of the diagram). The illustration, *b*, shows a figure in relation to the height of the stone bench and the risers of the steps.

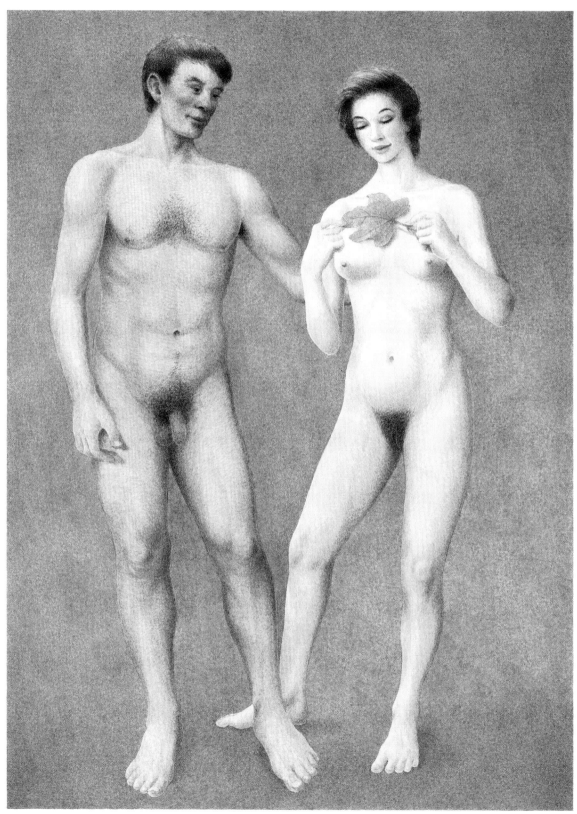

Plate 7 The male and female figure

Plate 8 Figures from different eyelevels

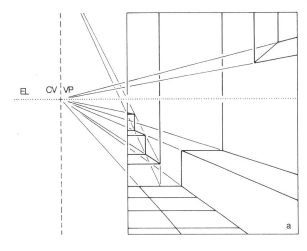

93 A simple interior in one-point perspective

Placing figures and their surroundings in correct relationship in perspective is necessary to create convincing interiors – whether these are taken from life or from your imagination. As aids in assessing this relationship it is sometimes worth using perspective grids so that objects may quickly be placed in scale. Grids are available in pad form from art shops, but these ready-made versions are expensive and frequently do not satisfy particular needs. Though constructing a grid is time-consuming, I prefer to make my own occasionally to use for specific projects. I save time by keeping a grid made for one picture in the hope I can use it again for another. But it has to be admitted that (as with bought pads) this rarely happens. Grids in one- and two-point perspective are included here and they are put to work as shown for the relevant illustrations. You may wish to enlarge them by photocopying to do similar exercises.

For the first example, fig. 94, a grid in one-point perspective, I chose to work with an interior view of a cube. The faces of the cube are subdivided by a combination of arithmetic and the projection of diagonals detailed for fig. 81. The cube was adapted from one I drew earlier by plan projection, but I might well have used other rectangular solids to produce different formats. For the cube, the eyelevel was placed at mid-height and the centre of vision

located at the dead centre. To select the number of divisions along each edge
I kept in mind the way that I wanted the composition to develop (fig. 95) –
four rows of units would appear on each face and as will become clear, for
equal spacing these would require a total of 17 divisions. Once the dimen-
sion of a side had been divided by 17 and the result measured out around the
periphery, I was able to move on to subdivision by diagonals as described for
fig. 81 – with lines projected to the VPs of the cube on the left and right.
These diagonals, taken from both the intended floor and the ceiling, meant
I could rule horizontals which in turn were divided into squares in perspec-
tive when lines were taken from all the perimeter points towards the CV
(halting at the back wall). Verticals dropped from the ceiling to the floor
divided up the walls. The squares of the back wall were made by connecting
all points as shown. This construction might appear complex, but it should
be easy to make your own version if you follow the above and also refer to
fig. 81.

The application of this grid is shown in fig. 95. I plotted the construction
by using translucent layout paper taped over the grid. The simplest route in

94 A cube interior grid in
one-point perspective

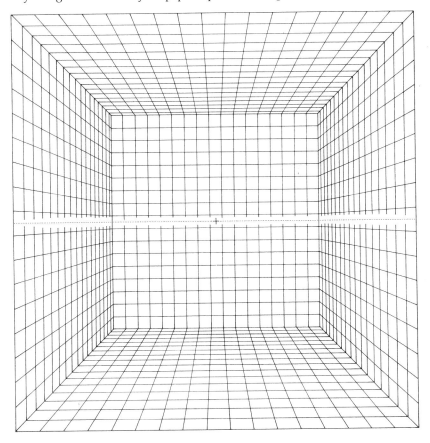

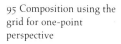

95 Composition using the grid for one-point perspective

such regular compositions is first to line in the units required in plan form on each surface. In this instance, I plotted a series of squares in perspective on the walls and floor, and long rectangles on the ceiling. Each square contained 2x2 grid divisions, and the rows of squares were separated by rows of 3 grid divisions. The ceiling rectangles were formed by lining in widths of 2 grid squares to the back wall again separated by rows of 3 grid divisions. Adding a third dimension was merely a matter of connecting the relevant points with horizontals, verticals, and converging parallels running towards the CV. This should become clear if you look closely at the drawing, although construction lines have been omitted because they would have made the drawing more difficult to follow. The composition was given scale and a hint of meaning by the addition of figures. The scene has become one of preparation – perhaps of a museum exhibit, or for a laboratory of some kind.

Though perspective grids may be used in drawing many topics, as mentioned, I tend to reserve their use for more complex subjects. A further example of an interior in one-point perspective, fig. 96, did not need the use of a grid, although the design does contain more elements than were used for the prison setting at the beginning of this section, fig. 93. In *a*, I have omitted the construction lines – convergence to the CV/VP will by now be obvious. I took the eyelevel height to be *c.* 173 cm (5 ft 6 ins) starting from a baseline (erased after use) placed just under the lower border – this estab-

96 Interior in one-point
perspective

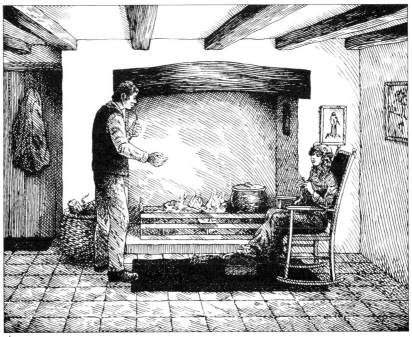

a

b

lished the scale of the work. After choosing the position of the CV, it was
easy then to draw the outlines of the walls etc. in proportion using converg-
ing parallels. The notional height of the EL was also used in placing the width
of the quarry tiles correctly. This was worked out arithmetically using the
distance from the baseline to the EL. The measure was then scaled off along
the baseline and converging lines were taken from these points towards the
CV, halting at the bottom of the wall. The depth of the first row of tiles was

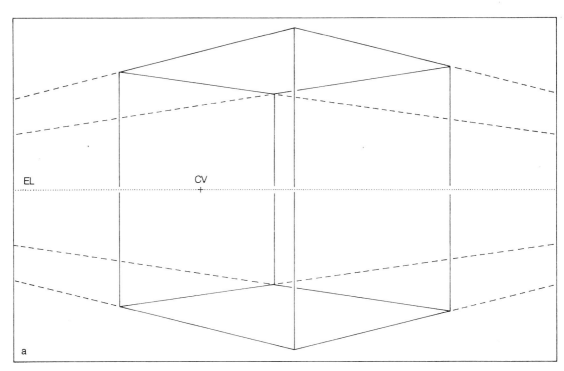

a

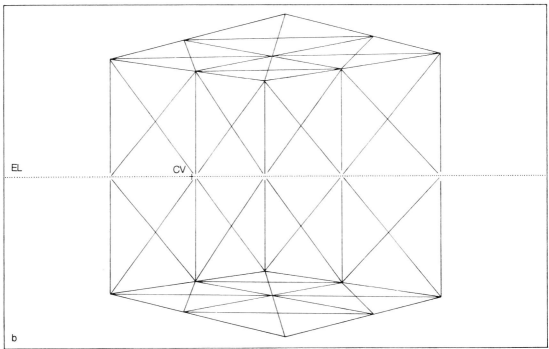

b

97 Steps in constructing an
interior grid in two-point
perspective

estimated from the baseline and the rest of the floor was completed using
diagonals as described for fig. 81. The baseline was placed slightly below the
lower margin because I did not want the line of the first row of tiles to appear
to coincide with the line of the border, although at a casual glance they appear
to do so. In *b* the room is completed by the addition of sparse furnishings as
well as figures.

The one-point perspective interior in fig. 96 was made without the use of
a grid, which is also not essential in drawing interiors in two-point perspec-
tive. Yet where a complicated composition is involved the use of a grid
becomes worthwhile. Fig. 97 shows how to start making one. For *a*, I have
scaled up an appropriately placed cube drawn earlier using plan projection.
(I should mention that it was only when I was most of the way through
constructing the grid that I noticed that the EL came halfway up the walls of
the cube. If the EL is taken to be that of a person of average height, this gives
an unusually high ceiling.) In *b* the beginnings of the subdivision of the
interior faces of the cube by diagonals are shown (the process was first
described for fig. 32). Fig. 98 is the completed two-point perspective grid. The
subdivision to this level might have remained within the confines of the cube,
but I wanted to use a larger space, and so by projecting lines the area in the
illustration was filled. Should you make a similar grid you will find that an
area may be extended as needed – this process is self-evident in practice
though a description would be lengthy and tedious to follow. As a corollary,
you are not committed to using the whole of the grid; portions may be
utilized to fit areas of differing proportions – though of course the EL and
CV will always retain the same relationship to their surroundings for any
particular grid.

As noted for the one-point perspective grid, the two-point grid in fig. 98
may also be enlarged or reduced by photocopying as required.

In fig. 99 I have drawn an ascetically furnished room using the grid in
fig. 98. As before, an overlay of layout paper was placed over the grid, the
drawing was completed and then traced through for the finished work. The
various components were entered in plan before showing three-dimensions.
I used the same means to space the window areas on the walls as well as to
position the door. The lines of the grid on the floor were projected in order
to give the required thickness of the wall. The table and benches were aligned
with the walls and floor so that I might take full advantage of the grid.
Heights of these units were determined by using squares below the window
spaces – keeping in mind the height of the EL. While it is not unusual for
major items within a room to follow the main lines, it would be uncommon
to have nothing breaking this alignment. As a contrast, I placed in the fore-
ground a small rectangle at a different orientation – for this I obviously had
to use different VPs from the rest of the composition.

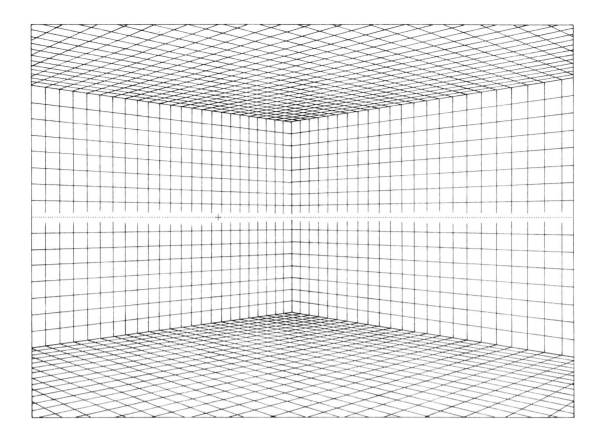

98 Interior grid in two-point perspective

opposite above
99 Stage in the application of a two-point perspective grid

opposite below
100 Completed composition derived from a two-point perspective grid

With most designs, I have a mental image of the intended end result at an early stage, and this was true of the room in fig. 100. I intended to use cowled and silent monks taking an austere meal. I had completed the setting when I remembered using monkish figures earlier (fig. 18) so I had to find other suitable people. The finished drawing shows a group of military fanatics of the type also much attracted to rigorous discipline. The window spaces have no glass and stone flags pave the floor. The only carpeting is around the plinth with the sculpted head of a leader. Incidentally, distortion was evident in the grid in the area of this plinth due to approaching the outer limits of the cone of vision (pp. 15–17). If you refer to the grid you will see that the left side of the plinth occupies the length of one side of a grid square in perspective. I have made the right side of the plinth equal to the width of two grid squares to give a more convincing balance. Had true perspective been followed here, the square base would have seemed unrealistically narrow. To avoid adjustments of this type it is really preferable to keep compositions more markedly within the cone of vision. The above stricture was kept to the fore in making fig. 101. Once more I used layout paper over the two-point perspective grid while the composition was arranged. To gain an extension of the foreground area I projected grid lines downwards beyond the border. The portion gained was still well inside the vertical dimensions of the cone of vision and so there was no distortion. In making the drawing I wanted to emphasize the point that, although in using a particular grid you are tied to the relationship of

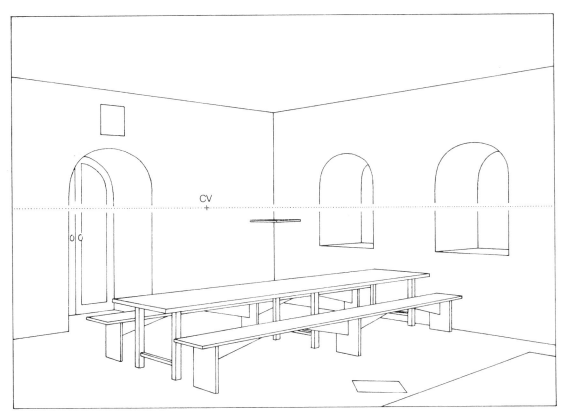

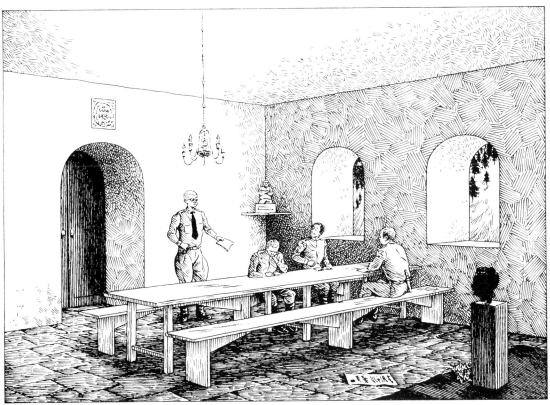

101 Drawing made using the central portion of the two-point perspective grid

the EL and CV to their surroundings, the scale is a matter of choice. Here the size of the little men is made obvious by the use of a matchbox, matches, skirting board, woodlice etc. The first dimension determined was that of the skirting board in the background. On roughing it in I decided that its real height, represented to scale, would be 120 mm. So, dividing its height at any point on the drawing by the grid squares covered, I found that each grid square had sides equivalent to 9.14 mm. The next step was to place the matchbox in plan using this scale, and then the height of the box was added by projecting lines across from the walls of the grid at the appropriate level. Once this framework had been drawn it was feasible to add the figures,

woodlice, and peeping spider – all to scale. I have not shown an intermediate phase before the completed drawing because in this instance the construction was very simple.

In fig. 101, the two-point perspective grid was used to simulate a tiny area in the corner of a room. It might equally well have been called upon to provide the other extreme – a vast interior. Both the one-point and two-point perspective grids may represent any scale desired. In this way, you have great scope without breaking the strict rules of perspective.

Should you have ample time you may wish to draw other grids using the methods described, changing the height of the EL and the position of the CV. At the same time remember that grids are merely tools to make work easier – they are not essential.

8 Reflections

opposite
102 Reflections and
perspective

Perfect reflections in still water often feature in the work of artists. Yet perfect reflections are uncommon – we have to wait for rare days of motionless air, or more often calm moments about dawn or dusk.

It is easy to absorb the essentials of the physical laws governing reflections. Effects are sometimes more difficult to follow. The angle at which a ray meets a reflecting surface is known as the angle of incidence. This angle is precisely the same as that of the ray returned to the eye, the angle of reflection. The main effect, as it concerns us, is that reflections occur directly opposite the subject and all points appear as far away from the reflecting surface as those on the actual subject. (Our eyes focus to the depth of the scene represented in the water or the mirror – and not on the surface, as might be expected – when we look at reflections.) But what we see reflected in a river etc. is not the same as what we see in the original, and the difference is due to perspective.

In fig.102 a scene reflected in water is built up in stages showing how the difference in perspective arises. In *a*, a simple rectangular solid in one-point perspective (p. 38) is placed on a bank represented by parallel lines. Next, in *b*, a roof is added (as shown in fig. 89) and the reflection of the building is shown in the water below. This drawing indicates the reason for the dissimilarities between the object and its reflection – both must conform to perspective laws. Receding parallels in both instances converge to the CV, but because the reflection is further away from the EL so its angles change, more is revealed of the interior and the outer face of the roof is no longer visible. To complete the building below in perspective, I have included the lines of the floor running under both the reflected bank, and the bank itself. In reality this part of the image would be obscured by the river bank – as it appears in *c*. In this part of the illustration further additions were made, the most important being the ramp sloping into the water. This incline from the surface behaves in perspective as illustrated in fig. 36, the receding parallels converge to a point on a vertical running through the CV. Correspondingly, the parallels of the ramp in reflection project to an equidistant point below the CV. Although the views differ, distances of points seen above and below the reflecting surface remain equal. As well as the ramp, a doorway, window etc. were added and these present no particular problems. The passing kingfisher in the foreground did give a small challenge – how big should it appear? As a first step I marked its chosen height of 225 mm above the surface. Taking the height of the doorway as 2.25 m (*c.* 7.5 ft) I was able to

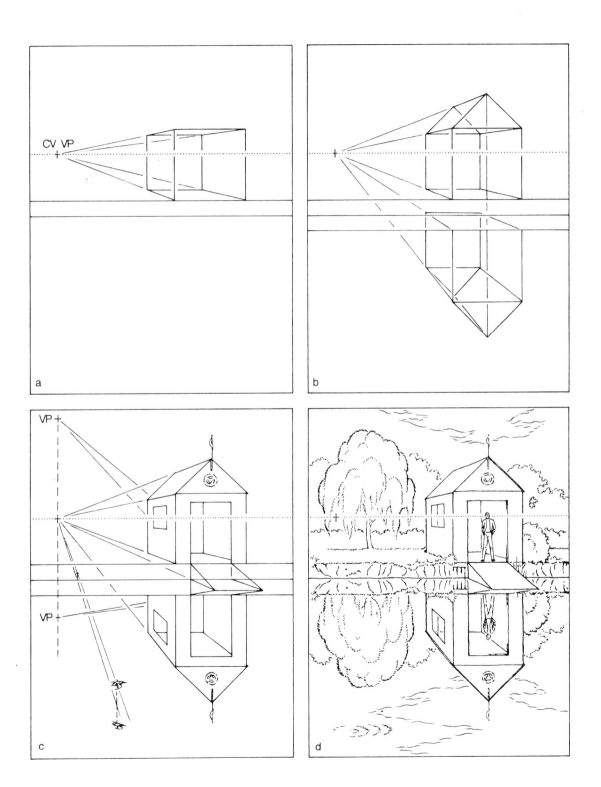

CV VP

a

b

VP

VP

c

d

scale off the required height on the river bank in line with the CV as shown. This measure was projected forward to fix the position of the bird above the surface and hence below in reflection. Given that the height of the bird above the water was 225 mm, it was easy to place the known length of a kingfisher (*c.* 165 mm) in correct proportion. Because of the observer's position the underside of the bird appears in the reflection.

In *d* the completed scene is shown (although I have left out any shading) – notice that the trunk of the willow and other details are not reflected since they are set back from the bank. This effect is detailed in the next illustration.

Fig. 103 shows figures set progressively further back from a river bank. Three lines converge to the CV. The upper line runs from the top of the bank and it represents the ground plane. The mid-line starts at the meeting of the bank and the water; projected back it may be interpreted as showing the position of the reflecting surface should the ground cover be stripped away. The bottom line follows the reflected bank where it would appear without the soil. The vertical line at the bank describes the vertical plane of the bank and its reflection below. The vertical under the seated figure is a repeat of the first in perspective – it is positioned beneath the central axis of the figure. The verticals under the other two figures have been similarly placed. Just as for the reflections in the previous illustration, the reflections of the set-back figures were affected by perspective.

To determine the dimensions of the reflections the axiom of, 'as above, so below' was applied – the height of the seated figure plus the bank thickness was taken from the junction of the mid-line with the set-back vertical axis line. This measure was then applied below to fix the maximum depth of the reflection in the water of the first fisherman. As for the detail of the reflection, this was a very different proposition from that of interpreting a reflected geometric form. As shown in the previous illustration with the boathouse, such forms may be easily shown in perspective by using simple perspective rules. In the present instance it was impossible to do other than imagine only in general terms how the figure might appear in altered perspective where the complex undersides of the hands and face would be partially exposed. To overcome this deficiency of information I thought it was sensible to introduce a slight breeze to disturb the surface and so blur the image.

The broken reflection of the second figure was established in the same way as the first: by taking the height of the man, with the depth of the bank, from the projected point of juncture with the water surface and repeating it below. As can be seen, in perspective the relative heights of the two men appear differently in reflection compared with the original forms.

The reflection of the woman in the middle distance does not appear because by applying her height together with that of the bank below the mid-line, it fell short of the river bank. The tree is also not reflected for the same reason.

The fine ripple blurring the reflections in fig. 103 was too slight to affect their length. A water surface more distinctly disturbed forms a series of inclined reflecting planes which have the effect of considerably lengthening reflections. With larger wavelets or waves, forms are broken into virtually abstract patterns bearing little relation to their origins.

103 Reflections from set-back figures

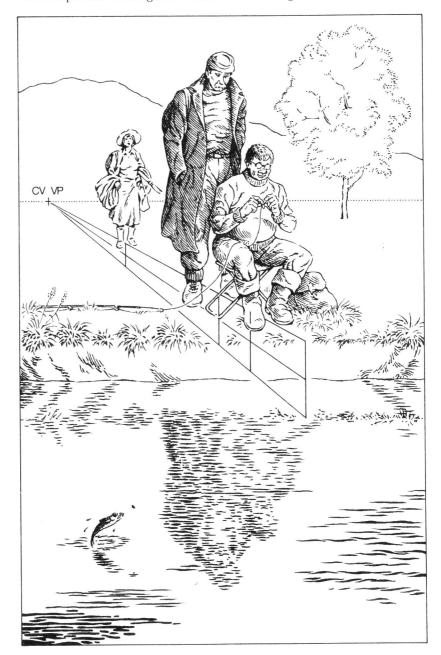

104 Reflections of a two-point perspective bridge

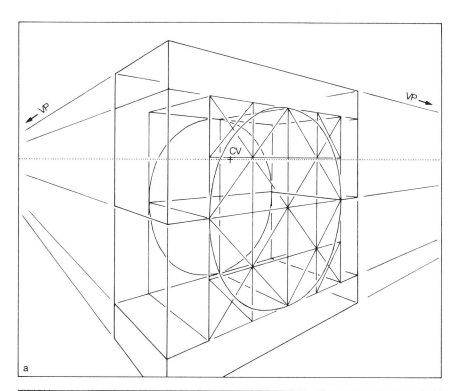

a

b

As a last exercise using reflections in water, a bridge is illustrated in fig. 104. In *a*, its construction is shown in two-point perspective. A rectangular solid was drawn using plan projection. The upper half represents the bridge and the lower part shows the reflection. The arch and its image completes a circle in perspective – constructed inside a square as described for figs 62 and 64. The span might have been given a different curve, but I thought that a half circle was the most pleasing shape. For clarity I omitted the construction lines from the rear end of the arch/reflection cylinder. Owing to the perspective used, more of the underside of the arch is exposed in the reflection than is seen in the upper section – this is more obvious in *b*.

In the completed drawing, abutments are added to the basic form together with a suggestion of stonework. The water surface is just lightly disturbed.

For this illustration a simple single span was used to show a bridge reflection constructed in perspective. More complex bridges and their reflections call for on the spot sketches or the use of photos.

Up to this point I have discussed reflections in water. In some respects these are less difficult to draw than reflections in mirrors. Ripples can be added to hide problem areas (fig. 103), but a mirror surface is uncompromising. As noted for water reflections, basic geometric forms are generally straightforward to draw in reflection from imagination if required. A cube etc. reflected in a mirror placed parallel to the picture plane is no more tricky to handle than the boathouse or the bridge already discussed. In contrast, irregularly shaped subjects such as people are almost impossible to treat accurately, showing both the original and the reflection in a mirror, without working from life or by using photography. This is accentuated if the plane of the mirror is angled in relation to the subject matter.

Fig. 105 shows ornaments reflected in a hand-mirror placed parallel to the picture plane. Initially, I had intended to use only the little china pig, but this seemed insufficient on its own, so I added the Greek owl. The stone base of the bird was a rectangular solid, almost a cube, and this enabled me to show both regular and irregular forms together.

If you follow the receding parallels of the cube, placed in one-point perspective, from the originals through their reflections, you will find the CV/VP just above the top left corner of the illustration. In drawing the reflected owl and pig I had to ensure that they also were in correct perspective. Key points were the top right extremity of the head of the owl, and the far left ham of the pig. These were established so that lines projected from the original points through their images, would also meet at the CV/VP. This relationship of objects and their reflections to the CV is constant, provided that the reflecting surface is parallel to the picture plane – and is applicable no matter how the original elements are arranged. Any points on the original may be used to project lines through their equivalents in the reflection to

reach the CV. Turning the base of the owl to view it in two-point perspec-
tive, the parallels of the sides converge in projection to meet at twin VPs on
the EL (pp. 45–6). The same sides in reflection then show parallels con-
verging to different VPs, though naturally on the same EL. At the same
time the relation to the CV of all points on the original and their reflections
remains as described. You may care to test this assertion by using the cube
of fig. 46 and a mirror (then see the effects of having the reflecting surface
sloping away from the picture plane instead of being parallel).

 The owl and the pig in fig. 105 confirm that such irregular forms shown
in reflection should be drawn by using models or photos. I might possibly
have fudged the frontal view of the owl without a visual reference, but the
foreshortened pig would have been too difficult to invent. Finally, notice that
in the illustration, as well as throughout this chapter, I have followed the
prime rule of placing the reflection at the same distance beyond the reflecting
surface as the original stands before it.

 See plate 5, p. 74, for a colour illustration of reflections. The subject, which
I found intrinsically interesting, also emphasizes the necessity of working
from models when attempting to show reflections from complicated objects.
In this example, using two mirrors, intense concentration was needed in
drawing the reflections because the upper mirror was inclined slightly to the
rear and the lower mirror, on which the objects were placed, was tilted to one
side. This meant that the reflected images were seen in different perspective
planes from the original. For any illustration using a similar arrange-
ment you would be well advised not to rely upon a construct from your
imagination.

9 Shadows

Since we are here primarily concerned with perspective, it is helpful to distinguish between shadows, in which the effects of perspective are often marked, and shading, where perspective elements are usually less obvious. Shading is a deepening of tone on the part of an object turned or obscured from the light. By comparison, shadows are areas of darker tone cast by the object on the side away from the light. These definitions are illustrated in fig. 106. The complete pattern of light, shade, and shadows, is known as *chiaroscuro*.

106 Shading and shadow

The nature of shadows is affected by whether the light comes from the sun or from an artificial source. Since the sun is so distant, its rays reach the earth in virtual parallels – though they should be visualized as converging in recession through perspective. This is also true for moonlight. In contrast,

any artificial light source is comparatively close, and rays more obviously radiate (laser beams excepted).

Shadows from sunlight

A constant in drawing shadows produced by sunlight is their inconstancy. They inevitably move, at times exasperatingly. When you portray a complex scene, well before completion the sun will have advanced appreciably along its path. Then a notional position should be adopted for the sun to avoid a confusing spread of shadow angles. In such instances, as well as when you are working from your imagination, it becomes important to understand how to construct shadows accurately.

In fig. 107 a cube is used to demonstrate how a shadow is cast by sunlight. Here, all the relevant components are included within the bounds of the diagram. More often you will find that VPs etc. may be positioned outside

107 Projection of shadow

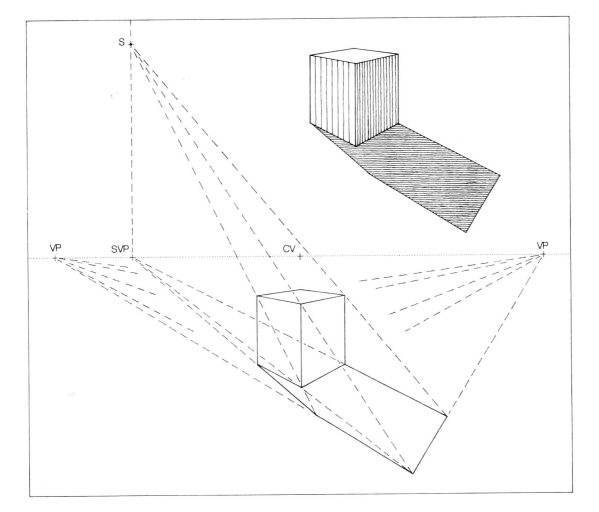

the area. The process used for the illustration is appropriate for many topics. After establishing the EL and CV in suitable positions a cube was constructed by estimation, as described for fig. 58. (Strictly, the 'cube' is more probably a rectangular solid because the lengths of the sides were placed by eye.) The form was convenient to use although any other rectangular solid would have served. I selected a position for the sun, keeping in view the desired effect. Rays from the sun were taken through the near upper corners of the cube down to the approximate position of the ground plane (fixed later). A line dropped from the sun intersected the EL to provide the VP for the shadow. This point is located immediately below the position of the sun. Lines were projected from the shadow VP (SVP) through the lower near corners of the cube to meet the rays from the sun. Linking the points of inter-section formed the outline of the shadow, finished above in tone. Notice that the edges of the shadow produced by the top of the cube remain parallel to the edges of the cube, and so they converge in perspective to the same VPs.

The above method is used where the sun appears in any position to the front of the observer. Often the sun is to the rear and the solution to this small complication is shown in fig. 108. The EL, CV, and cube were estab-lished as before, then, in order to plot the shadow I had to assign a position for the sun on the working surface. This point was placed at the same distance

108 Projection of shadow with the sun behind the observer

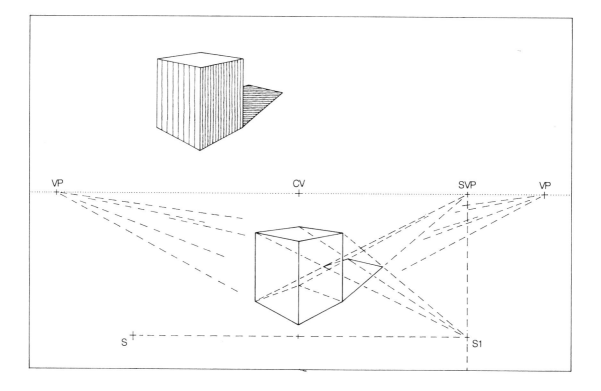

below the EL as the sun was assumed to be above it. Next, the sun, S, was projected from its position to the left and below the CV to a point equidistant on the right, S1. From S1 lines were taken to upper corners of the cube. A vertical erected from S1 to intersect the EL gave the SVP. Points of junction of the lines from S1 and SVP were joined to form the shadow outline – again shown in tone above.

Fig. 109a–d, shows various arrangements of shadows cast by a cube, plotted as described for fig. 107. In e, I have pictured a sphere with its shadow. It would be feasible to make an exact construction by first placing the sphere within a cube, and then projecting key points as already described. This process would have been ludicrously protracted considering the end result, and so I used a short-cut appropriate for almost all purposes. A small ball was positioned conveniently in relation to the sun. The drawing was made by entering the circular outline of the sphere, and then estimating the position of the axis. I projected a line representing a ray of sunlight passing through the axis apex to meet the ground plane. This positioned the extreme edge of the shadow. The rest of the ellipse was drawn by eye.

I suggest that you experiment with producing shadow forms by placing the model cube (fig. 46) in various positions in relation to the sun. This also may be done with a sphere, but as the shadows produced from any given angle of the sun will remain the same no matter how the sphere is turned, it is necessary instead to alter your own position. By raising or lowering your EL and moving around the sphere you will alter the apparent shape of the ellipse.

Cubes and spheres have been useful in demonstrating correctly drawn shadows. Now the same methods are applied to more developed subjects. In fig. 110a, a house form is shown with its cast shadow. The shadow outline was fixed by using lines projected from the position of the sun, lines from the SVP (established as described above) and the two-point perspective lines to the VPs. The sun, SVP and VPs were all outside the diagram area – their positions may be found by projecting the broken lines back to their points of origin. Notice how the chimney shadow was placed: lines were taken from the SVP through the corners of the chimney base to intersect with other lines running from the sun through the corners of the chimney top. Inside the main shadow, to the right of the chimney outline, I have indicated the position of the left front corner of the roof in shadow. This was included to show how it corresponds to the exposed foreshortened roof shadow on the left. The angle at the base of the shadow represents the right roof apex. In b, I have emphasized the pattern in tone.

Fig. 111 shows the basic house form of the previous illustration in a rural setting. While working on the composition, although the size of the house remained the same, I altered the scale from my original intention. The

109 Shadows cast by cubes
and spheres

opposite above
110 House form and
shadows

opposite below
111 A composition including
a house and shadows

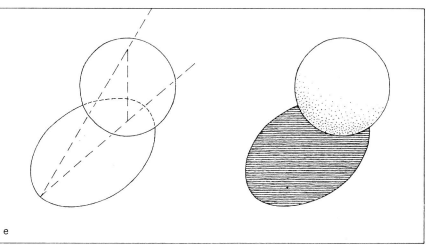

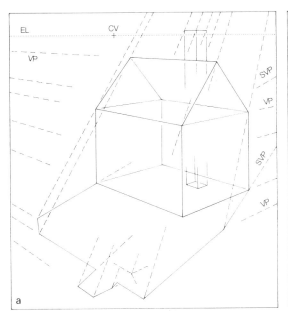

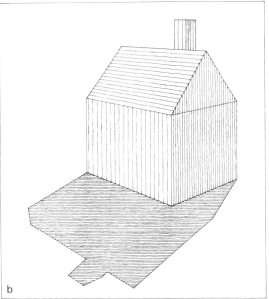

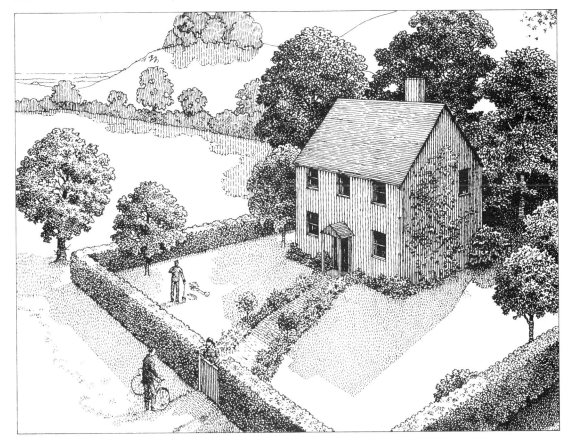

112 Latitude in interpreting a shadow from an irregular form

113 Shadows on slopes

chimney in the new format appeared too large, and so I trimmed it down somewhat. The shadow of the trees, hedge and figures were constructed using the SVP and sun position as before. Except the hedge, these forms were irregular and so their shadows were necessarily generalized. As discussed earlier for reflections, with such irregular forms it is pointless to try to follow every nuance of their shadow outlines; the many variables involved have effects that are impossible to assess. This is illustrated in fig. 112 where the shadow cast by the figure on the left was accurately drawn from a photograph. For the figure on the right the shadow was distorted, although at a casual glance it looks more convincing.

In the above examples, the shadows have been cast upon a level ground plane. Shadows on a sloped surface are shown in fig. 113. In *a*, the shadow falls on the roof below the chimney stack with the rays of the sun parallel to the picture plane. I easily fixed the lower edge of the shadow by projecting the sloping line of the roof at the chimney base until it intersected the rays. The same process was followed in *b*, again with the sun's rays parallel to the picture plane. Had the sun been orientated differently, so that its rays were at an angle to the picture plane, then the method shown in fig. 107 would have been used – except that the SVP would then have been raised above the EL according to the slope of the roof.

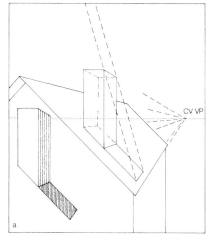

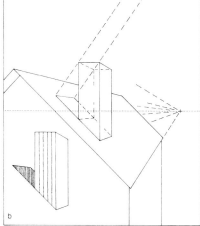

Shadows from artificial light

There are several important differences between shadows cast by objects in sunlight and those derived from artificial light sources. As noted earlier, owing to the distance of the sun its rays as they reach us are taken to be parallel – although converging in perspective. In contrast, any artificial light source will be close enough to the observer for the spread of its rays to be apparent (except lasers). Distortion of shadow outlines becomes progressively greater in proportion to their distance from the source. Also,

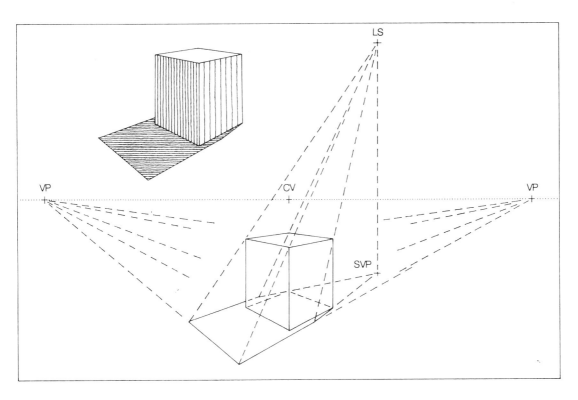

114 Shadows from an
artificial light source

although the edges of shadows will be crisp at the point of contact, they
become diffuse with recession. As with sunlight, the SVP is located directly
beneath the source. Yet it differs by not being on the EL but on the ground
plane of the object.

Another feature of shadows produced from artificial light (and sometimes
from diffused sunlight) is that there may be a deeper toned core, the umbra,
surrounded by an outer lighter area, the penumbra. This effect is often
present where more than one light source is used (see below).

In fig. 114 I have again used a cube to show the way to construct a cast
shadow when working with artificial light. The position of the SVP on the
ground plane is the key feature to note; it is never on the EL other than by
chance. In making the drawing, a vertical was dropped from the light source,
LS. The position of the SVP on this vertical depended on the distance of the
light from the observer – had the SVP been higher in relation to the EL this
would have implied a more distant light source, and of course the opposite
applies. To pinpoint the position of the light would have entailed the
unnecessary construction of the room about the cube.

For most rooms, shadows exist on different levels in addition to the ground
plane – on tables, bookshelves, etc. Each shadow has to have its own SVP
placed up or down the vertical from the LS. This tedious exercise is made

115 Shadows from multiple
light sources

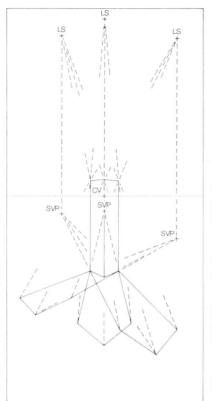

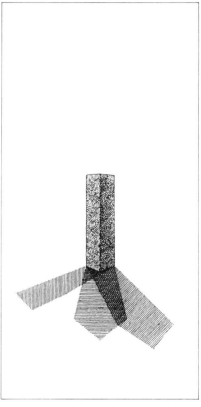

115 Shadows from multiple light sources

worse when light comes from multiple sources. Such subjects are best drawn from life, bearing in mind the principles involved. In imaginary constructs blurring is sensible.

For simple themes multiple light sources are feasible, but only just. Fig. 115 shows a column under three lights. In *a*, I have omitted the two-point perspective lines for the pillar, and only the beginnings and ends of the traces are included. Even so, there is a confusing network of lines. Had the original form been complex, the resulting tangle would have been very confusing. If you do your own version of this exercise, you will probably find that blurring is useful for any drawing of such complexity.

The colour plate on p. 75 shows a shadow projected by an artificial light source close to and on the right of the subject. (Drawing was made more difficult by the relatively rapid opening of the sweet pea flower under the stimuli of added warmth and light.)

10 Anatomy

The elements of perspective as described in the preceding pages will particularly assist you in drawing landscapes and buildings. Naturally, perspective laws also apply to the human form – although its complicated outline may present more problems in comparison with geometric solids. Some authors suggest virtually breaking the figure down into a series of cylinders as shown in fig. 75. I find that it is better simply to keep in mind that the limbs and trunk are roughly cylindrical.

In spite of the difficulty of relating the body as a whole to geometric form, the dictates of perspective should be observed if you are to achieve convincing results. This theme is expanded later.

Before attempting to draw the human figure in perspective it is preferable to have some knowledge of its construction, even if you do not aim at expertise. This chapter is an introduction to the topic as well as a ready reference. I have avoided scientific names as they are not relevant at this stage.

I suggest that you draw from life as much as you can in order to gain some fluency. If access to a life class is impractical, ask friends and relatives to sit for you. Photographs are a second-rate substitute, although today their use is inevitable, especially for illustrations. Working mainly from life will give you the ingrained knowledge to enable you to use creatively occasional photo references rather than slavishly copying them.

The skeleton

The body's bone structure dictates appearance to a marked extent. In places it is close to the surface, in others it is lost beneath muscle layers or, perhaps more often, fat. Proportions change from birth to early maturity, and then remain more or less stable through adult years until the degeneration that can come with old age.

Fig. 116 shows front and back views of the skeleton of an adult male. Female structure differs slightly, most obviously in the width of the pelvis in relation to the shoulders.

Musculature

As demonstrated in fig. 117, the arrangement of muscles about the body is an intricate matter. Males and females have muscles similarly placed although in males their development is usually, but not invariably, more obvious. In the illustration a mature male is drawn to show a nicely balanced musculature on a sturdy underlying frame. In working from life you will soon recognize how the arrangement and movement of the muscles influence the appearance of the body surface.

116 Skeletal structure

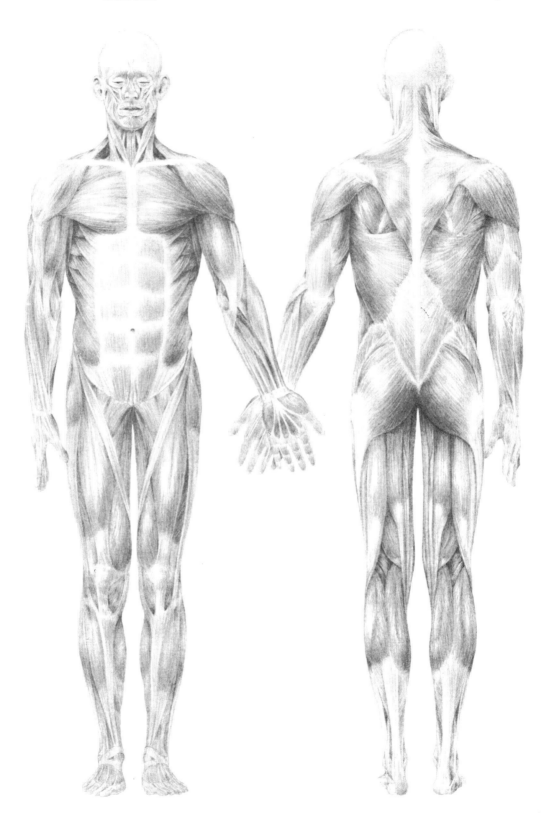

117 Musculature

Proportions

Correct proportions are as important in the figure work of an artist as are skeletal structure and musculature. A drawing will fail to be convincing unless the parts are in correct proportion to each other.

The length of the head is accepted as the most useful index. In a baby the head is about a quarter of the body length, then as growth continues this ratio changes, as indicated in fig. 118. The little girl on the right is shown at just over two years old: her head fits into her body length 4.75 times. The boy was drawn at three and a half years and his head to body ratio is about 1 to 5. Although the fourteen-year-old girl has a mature sized skull, it divides into her height 6.7 times – still short of the adult scale. The grown male to the left has a head that fits evenly 8 times into his body length. Many artists use this measure as a general rule, although a ratio of 1 to 7.5 is probably more accurate. In the illustration the head of the man is drawn fractionally larger than that of the teenager, although here the 1 to 7.5 scale would probably have looked more appropriate. In drawing from life I try always to follow actual proportions while keeping in mind the above ratios. For imaginative work I normally start with the 1 to 8 proportion and then add just a little more to the head length.

Another useful marker is the position of the mid-point of the body at the pubic bone (immediately above the genitals in both sexes). In a baby this point is higher, being close to the navel. As the child grows so the mid-point lowers towards the pubes.

On the adult frame there are a few other features that may usefully be placed by using the 1 to 8 head scale. Notice that for the man in the illustration, working down the body, the nipples are sited a little below the second division. For a woman, the position of the nipples may vary depending upon the form of the breasts. Elbows appear at about the 3-head-length position. The tips of the fingers on the relaxed arm fall at roughly mid-thigh, just above the fifth division, and the knee is above the sixth line.

There are other proportions and units according to various systems, but I have found them too clumsy for everyday use. Remember that, although the above measures are generally applicable, there are considerable departures from the norm. Professional fashion models, for instance, sometimes boast a 1 to 9 head-to-body-length ratio, so giving an elegantly etiolated silhouette. Somewhat ideal forms are illustrated in the colour plate on p. 78.

After considering the foregoing you may wonder how you should actually begin a figure drawing. After positioning your model in a pose that may be held comfortably, start by entering your eyelevel line, then rough in the head as a lightly drawn oval as shown in fig. 119. Go on to establish the lines of the spine, shoulders, hips etc. At this stage I use lines that are barely visible; here they are drawn more firmly for clarity. Proportions may be checked

before detail is added. From the very beginning attention should be paid to balancing the body, as described below.

Balance

Unless figures are caught in particular phases of violent movement, they are normally shown balanced in relation to their surroundings. Fig. 120 illustrates some commonly seen positions. The man on the left has his weight distributed evenly on legs placed equally on each side of the axis. In this pose the shoulders and hips remain parallel to the ground. The following two sketches illustrate what happens when the body weight is thrown on to one foot. The head and the load-bearing foot become aligned; the pelvis tilts as it is impelled upwards on one side and pulled down by the relaxed leg on the other; in compensation the shoulders slope in the opposite direction to maintain balance. The same process is pictured from the rear in the next drawing – this time the weight is on the other foot.

The angles of the pelvis and shoulders are usually seen as I have illustrated them although sometimes, even when the body weight is mainly carried by one leg, the shoulder slope may be altered or even negated by a redistribution of load through positioning of the trunk or arms.

A main axis is also shown for the walking and sitting figures, although in such instances its placement is more a matter of judgement. The important point is that no matter what pose your model adopts you should be sure that you accurately reflect the unconscious postural adjustments that have been made in order to maintain balance. By doing so you will avoid the error of having a subject apparently about to topple.

Movement

In achieving and maintaining balance, as well as in carrying out all the other demands placed on the body, we move various parts as required. Each movement involves positional changes in the appropriate set of bones with the muscles contracting or relaxing according to their load.

Fig. 121 looks at what happens to the appearance of arms and legs as muscles are flexed or bones moved. In *a* the muscles of the whole arm are tensed with the limb in a position to show maximum muscle definition. By contrast, in *b* it might be thought that the muscles appear relaxed, but if you hold your arm in the position shown you will find that most are under tension. Again, this time to assess bone movement, try holding your arm and hand as figured in the upper sketch in *c*. Then flip your hand over to the position shown in the lower drawing – this requires a major transposition of the bones of the forearm. Legs are similarly affected in movement; great changes in appearance may be made by alterations in position as illustrated in *d* and *e*.

It would be outside the scope of this book to attempt to go more deeply into this topic here. Fig. 121 merely indicates how underlying skeletal structure and musculature influence and alter surface appearance according to movement. A useful exercise is to use a mirror and sketchbook to record some of the almost infinite variations to be seen in your own body.

Movement in the sense used above refers to changes in the positions of limbs etc. If you wish to draw the moving body, as in walking or running, it is sensible to use photo references. But do use them creatively – as knowledge grows you will be able to alter as you wish, and to make appropriate

121 Limbs and movement

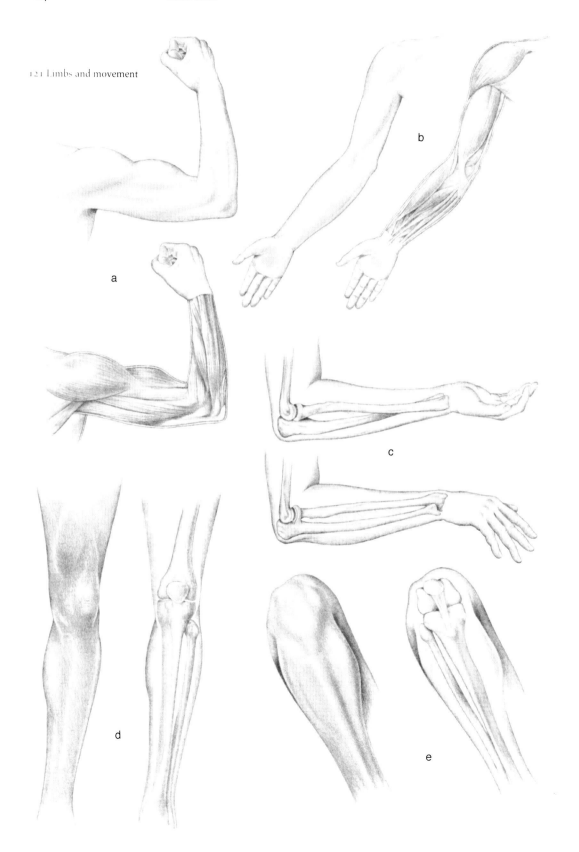

a

b

c

d

e

122 Leaping man

compensations, as your design requires. Use a photograph as a beginning and not as an end in itself; in this way you will be exploring potential and not merely imitating. Fig. 122 is an example of such treatment. Notice how, in the drawing, muscle groups are shown tensed to indicate maximum exertion. Also, note how the low eyelevel implies that the leap is high.

As you draw the body, consider it as a whole, but also appreciate the structure of component parts. Some features are discussed in more detail below.

Heads

When working on the head, always be sure that it is properly placed on the shoulders by giving due attention to the neck. At the top of fig. 123 details of the neck muscles are given. The key ones are those that originate behind each ear to descend in powerful flexible twin bands to their lower points of attachment at the upper margin of the breast bone. At this anchor point they form a clear V-shaped notch visible between the collar bones, unless the subject is obese. This notch serves as a useful marker in judging dimensions. The two muscle bands help in turning the head: as one tenses and becomes defined, the other relaxes and then may be difficult to pick out.

123 The head in different positions

The illustration continues with four heads and shoulders with the necks held at maximum angles. In all but one drawing the muscle bands are prominent; the exception is the passively dropped head which allows the muscles to relax and to become less obvious.

Necks may convey distinct impressions: a slender frail one suggests physical weakness and vulnerability; at the other extreme a 'bull-neck' speaks of animal power and strength. Another aspect sometimes useful to the artist is that necks show the effects of age – while the face may remain almost unmarked, the neck reveals all.

After placing the head, the features may be added using the divisions illustrated at the top of fig. 124. These divisions are helpful to use as general guides: individual proportions may differ. The main point of the first head is that the eyes are sited midway between the top of the skull and the base of the chin. You may find this surprising – many people erroneously put in the eyes at too high a level. The other key division is the beginning of the natural hairline. This may usefully be assumed to be a sixth of the distance from the top of the head to the base, although of course in reality there is considerable variation. The relevance of this one-sixth measure is seen in the next two heads where the hairline marks the point from which the face

124 Heads

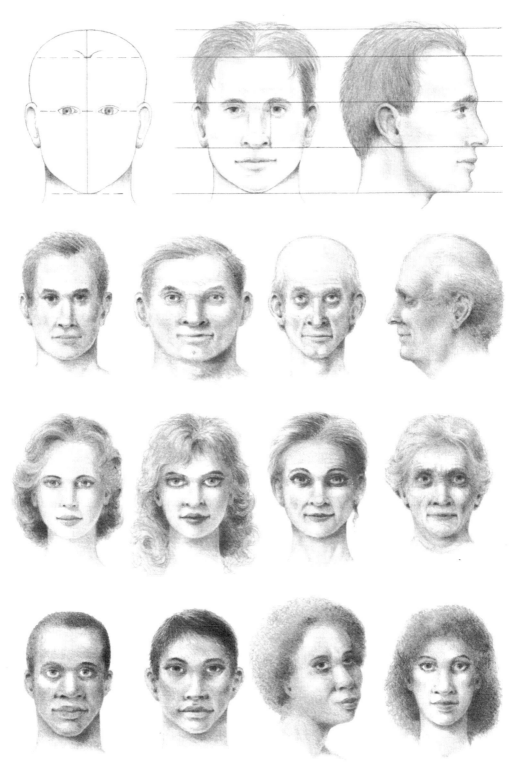

opposite
125 Expressions

may be divided into thirds. The top third includes the forehead and extends to about the upper margins of the eye sockets; the second division contains the eyes and continues to the base of the nose; the final band defines the position of the mouth.

The second and third rows of heads show the divisions in application, even though the lateral measures and other dimensions differ considerably.

Although the above proportions are broadly suitable for most Caucasian types, you will find them less apt for other racial groups. It is impossible to lay down rigid rules regarding dimensions and proportions in order to differentiate according to race – and so the final line of faces do not quite fit the division into thirds used above.

Expressions

In fig. 125 four rows of standardized heads are used to illustrate four emotional states: pleasure, sadness, anger, fear. The faces on the left have features just slipping from a neutral repose, then expressions gradually change until the extremes are illustrated on the right. While the emotions signified in the right-hand faces are obvious and relatively easy to capture, it is when feelings are nascent in the face that they pose more challenges for the artist. In the features on the left, from the top to the bottom of the page, you will see that mood is revealed by relatively tiny changes in the eyebrows, eyelids, pupils, nostrils, and lips. Although the illustration shows only basic expressions, it does indicate that if you are interested in portraiture, every mark you make will contribute something towards the end result. Success may lie in recognizing telling details – such as 'smile' wrinkles mellowing otherwise austere features, or perhaps lines which hint at a less inviting personality.

Features

Individual features may give problems, and here you will find that the maxim 'drawing is knowing' is endorsed. Fig. 126 shows various eyes, noses, mouths, and ears. Some are from males, others from females (sexual differentiation is often not evident in particular components). It is really only by drawing over and over with concentrated awareness that the subtlety of the structures may be absorbed.

In the illustration I have not attempted to reflect the dramatic range of form in noses, mouths and ears. Curiously, eyes, while being intensely expressive, do not vary much in their fundamental morphology. Yet ears, treated often as mere blurs, exhibit a huge diversity – many being so beautiful and interesting that they would make worthy subjects on their own.

We are all able to differentiate between very many faces through the individuality of features in their setting of overall skull form, hair colour, skin shade etc. To catch a likeness you should be conscious of these factors.

126 Eyes, noses, mouths, ears

Be ready to give prominence to some that are most characteristic of the sitter while perhaps toning down others.

Feet and hands

Many would-be artists fudge feet and hands – they are not the easiest subjects. In the upper part of fig. 127 feet are shown in several positions. The following points are helpful to keep in mind while working. Notice the smooth curve described by the line of the toes. Also, see how the inner ankle bone is set higher than the outer. In the feet shown in profile the heel is drawn as a definite projection rearwards – this feature is sometimes missed.

127 Feet and hands

Watch for the changes in bones, muscles and tendons as the feet move, and the effects of foreshortening (see p. 124).

As for hands, again the path to success is through practice. Try drawing your own hand laid flat on the table beside you. Note especially the relative finger lengths and the disposition of the joints – these proportions are quite consistent while actual dimensions are not. Then turn your hand to expose the palm for another view. Both these aspects are shown in the illustration. Further useful poses can be found by using a mirror.

Figures in
perspective

Throughout this book figures have been shown in perspective contexts, and in every instance it has been vital to make the perspective of the figure conform with that of its setting. Because our bodies are so irregular in outline – with limbs that may be disposed every which way – it is generally impractical to fit them into any specific geometric framework that would assist their portrayal in perspective. For this reason it is usually sensible to relate the figure to its background perspective whether or not the setting is included in your work. It was noted earlier that when starting to draw the figure you should enter your eyelevel. By doing so you can fix appropriate vanishing points for your interior or exterior views (pp. 68–89). You will then also be able to place VPs for certain alignments on any figure that is positioned to provide receding parallels. This is demonstrated in fig. 128 where a rectangular solid has been erected around a standing man using the estimation system given on pp. 47–8. A number of parallels are taken to a VP using the lines of brows, lips, shoulders, nipples, hips and knees. The elliptical cross-sections of thigh and calf are also drawn in perspective.

I must stress that except for special situations, boxing-in a figure as above is quite unnecessary – the point to be made is simply that certain features, provided that they are parallel to the ground plane, may be projected to a VP on the eyelevel to ensure accuracy. Although for realism the perspective of

128 The figure in
perspective

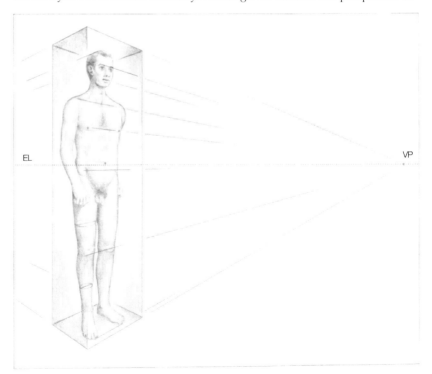

129 Placing figures in
perspective

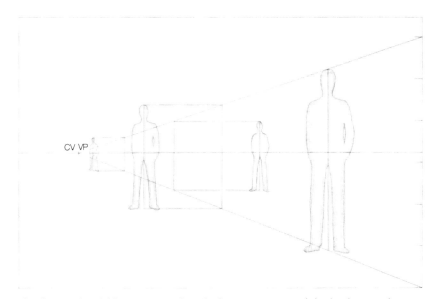

CV VP

the figure should be integrated with the perspective of the background, it is impossible to give more definite rules for everyday use. Given that virtually all main body parts may be positioned at different angles, it is obvious that their perspective may best be followed by keen observation. Nevertheless, there are a few helpful pointers. I find that for the standing figure, once the feet are correctly aligned on the ground plane the rest follows relatively easily. Again, in drawing a seated form, the figure should be carefully related to the perspective of the chair. Another tip is to place the model parallel to a main background feature, such as a wall or a door, so that its easily determined VP may also be used for the previously noted lines of the body.

The colour plate on p. 79 shows some situations where the figures themselves play major roles in determining the perspective appearance of their surroundings. In the top panel the central figure in relation to the eyelevel has set the measure for all the other people (the mechanism is detailed in fig. 129). For the lower left panel, the near figure on the right is viewed from a normal eyelevel, but here the giant distorts our perception somewhat. The people in the scene on the right are looked at as if from the captive in the bag carried by the giant. Here the man holding the camera provided the prime dimension in relation to the high EL.

Fig. 129 illustrates how figures may be drawn at their correct relative sizes in perspective before the surroundings are added. A measuring scale has been drawn on the right (this may be any size or placed in any vertical position according to preference). Lines from the top and the bottom of the scale run to the chosen site for the CV/VP on the EL. The rest is self-evident. For clarity only four figures have been used although any number may be added.

130 Foreshortening

Foreshortening and the figure

Foreshortening is defined on p. 22, and its effects are easily appreciated. Unfortunately, again due to the irregularity of the contours of the body, it is not feasible to lay down clear precepts for drawing the foreshortened figure or its parts. A great deal depends upon the position and distance of the observer in relation to the figure (see also figs 77 and 87*b*). In the examples illustrated in fig. 130 we are placed at a comfortable distance so that the foreshortening, although marked, is not extreme. Had we been placed close to and on a level with the feet of the nude woman, for instance, they might have filled our visual field to the exclusion of all but a fraction of hip etc. protruding in foreshortened view from the edges of the soles. The hand and arm on the right are mine, seen in a mirror; the hand is logically proportioned, given its proximity to the viewer and the foreshortened forearm, although it is still appreciably larger than the example above portrayed from further away.

Although the above sketches were made specifically to show the phenomenon, *any* view of the body will include foreshortened portions. As with the general perspective of the body the best advice is to observe carefully and to record accurately. Remember that we always tend to discount foreshortening to some extent. It is axiomatic that in the foreshortened form dimensions are a lot less than we feel that they ought to be. As an example, the distance on the paper between the left heel and the hip of the nude in the illustration would have been much greater had I listened to my mind's interpretation rather than using my eye accurately to fix these points in relation to others. Always relate shapes distorted by foreshortening to fixed points in the surroundings to counter this natural tendency.

Index

Colour plate page numbers are in italics; black and white illustrations are not indexed, they are placed close to relevant passages.